# BASICS

## CREATIVE PHOTOGRAPHY

### 03

# BEHIND THE
# IMAGE

RESEARCH IN PHOTOGRAPHY

**Ethical:** aware-
ness/
reflect-
ion/
debate

academia

Book

Published by AVA Publishing SA
Rue des Fontenailles 16
Case Postale
1000 Lausanne 6
Switzerland
Tel: +41 786 005 109
Email: enquiries@avabooks.com

Distributed by Thames & Hudson (ex-North America)
181a High Holborn
London WC1V 7QX
United Kingdom
Tel: +44 20 7845 5000
Fax: +44 20 7845 5055
Email: sales@thameshudson.co.uk
www.thamesandhudson.com

Distributed in the USA & Canada by:
Ingram Publisher Services Inc.
1 Ingram Blvd.
La Vergne TN 37086
USA
Tel: +1 866 400 5351
Fax: +1 800 838 1149
Email: customer.service@ingrampublisherservices.com

English Language Support Office
AVA Publishing (UK) Ltd.
Tel: +44 1903 204 455
Email: enquiries@avabooks.com

© AVA Publishing SA 2012

ISBN 978-2-940411-66-5

Library of Congress Cataloging-in-Publication Data
Caruana, Natasha; Fox, Anna.
Basics Creative Photography 03: Behind the Image:
Research in Photography / Natasha Caruana, Anna Fox p. cm.
Includes bibliographical references and index.
ISBN: 9782940411665 (pbk.:alk.paper)
eISBN: 9782940447312
1.Photography--Handbooks, manuals etc. 2.Photography--Study
and teaching. 3.Photography--Research.
TR146 .C378  2012

10 9 8 7 6 5 4 3 2 1

Design: an Atelier project, www.atelier.ie
Cover image: Ellie Davies

Production by AVA Book Production Pte. Ltd., Singapore
Tel: +65 6334 8173 Fax: +65 6259 9830
Email: production@avabooks.com.sg

Printed in China

**Title: Beyond the View 8**

**Artist: Helen Sear**

For her series 'Beyond the View',
artist Helen Sear worked through
a process of digital layering and
drawing after she had taken
the photographs, to create
stunning imaginary spaces. The
viewer, caught up in the beauty
of the image, is encouraged
to contemplate the complexity
of looking, the view (from the
perspective of the woman in the
image), and identity. All of Sear's
portraits in this series are of women.

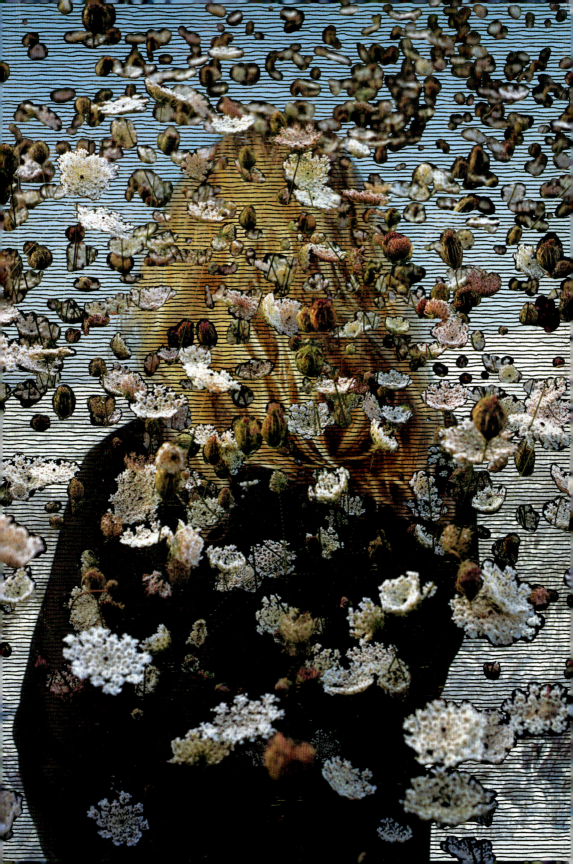

# Contents

## 4

## 5

## 6

Research and exploration are vital elements of the photographer's practice; together they form part of the process of making photographic projects. Photographers can carry out their research in many different ways, but essentially, a body of photographic work is developed through knowledge gained in exploring the medium: investigating histories and theories of photography, observing the world, reading and listening, taking part in debate, critical reflection and numerous other activities. This book introduces a range of research methods for photography and suggests new ways of thinking about the medium.

Finding out how other photographers work, what informs them, why they are passionate about the work they do and how they produce their photographs is a truly exciting part of the research process. Photographers model the way they work on the knowledge they have gained about how others operate. There is really no such thing as an 'original' idea – all ideas have been informed by looking at or studying other things as well as experimenting with the medium.

It can be tempting to think that research is not relevant to your work, but if you think carefully and spend some time reflecting on a recent piece of work, it is possible to trace how the project has evolved. What were its influences? How did the project start? What might have been happening in the world at the time the work was made? Were you reading a particular book, watching a memorable programme or did you see something that affected you? All of these questions can influence the development of a body of work. Once you understand the value of research and what it can be, it makes sense to start recording the research process. Documenting the process for the future enables critical reflection, and the evaluation of what you have done helps you decide where to go next.

0.1

**Title: *from* 'Ever After'**

Artist: Wiebke Leister

Leister's project 'Lovers, Liars and Laughter' extends her earlier research interest in the mouth and the photographic portrayal of laughing and smiling, to look at the rather invisible and unattainable features of love and kissing. Leister works with a variety of media including drawing, photography, collage and writing (both academic and fiction).

A body of photographic work is developed through knowledge gained in exploring the medium.

0.1

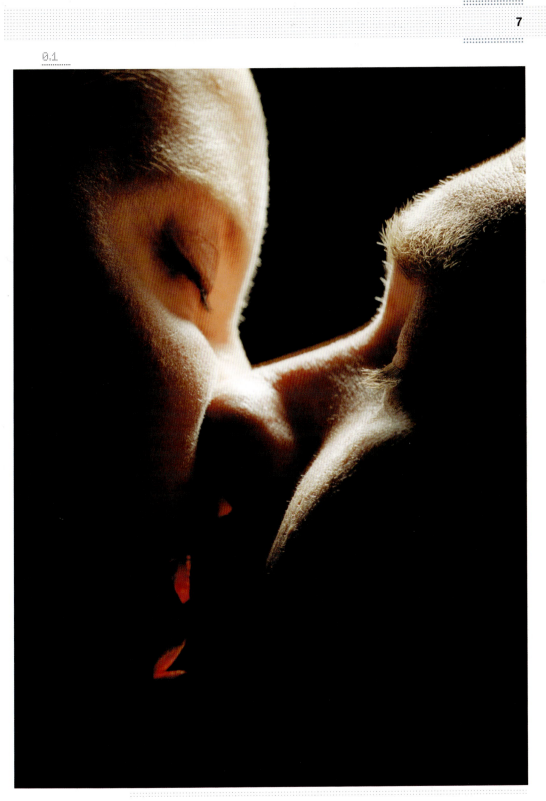

## Planning

The first chapter takes a close look at the initial stages of the research process – planning your project, researching historical contexts and exploring relevant theory. It encourages you to consider the reasons you have for making your work. The importance of considering and articulating what you want to do and why is introduced in the context of proposal writing. Budget preparation and timetabling are discussed as part of the written proposal.

## Developing ideas through research

The second chapter investigates a range of potential research tools, places to visit and things to do as part of the research process. The value of the widest range of resources is considered, as well as how to get the most out of each one. It looks at where to find what you need and how to develop a framework for research. The value of archives, museums and the Internet is discussed, as well as conducting interactive research.

## Practice as research

What does practice-based research mean? Having looked at the early stages of planning, this chapter concentrates on exploring practice and looks at how it relates to other forms of research. Genre and style are explored, and editing is brought into the discussion as a way of analysing practice. This chapter also examines how continuous evaluation informs the development of a body of work and shows that critical reflection is valuable at every stage.

## Compiling your research

Making a record of your research is invaluable. To make the most of the work you have done, it is vital to find ways of bringing order to your research materials. There are many different ways of doing this and there is scope to develop your own personal method. This chapter looks at some of the available methods for compiling your research, including workbooks, sketchbooks, archives and blogs.

## Research and practice

Research and practice are intrinsically linked and form a continuous working process, sparking new ideas and innovative ways of working. This chapter explores the connection between research and practice and considers how all aspects of thinking, researching and producing are parts of the process. The importance of taking time to reflect on your research is explored, as well as how revisiting past research and modifying an existing plan can benefit your projects. Context and audience are discussed, and the importance of research ethics is highlighted.

## The impact of research

Research is meaningful, and methods of evaluating and reflecting on your research allow you to improve your future work. This final chapter looks at the value that has been placed on research in the contemporary world, in archives as well as the display of photographers' research in exhibitions. Today's curators are keen to make us aware of the work that goes on behind the making of photographs and to emphasize that a single great image has not been made in a vacuum.

0.2

**Title: *from* 'Workstations'**

Photographer: Anna Fox

The 'Workstations' series, shot in the late 1980s, documented London office life at the end of the Thatcher era. The photographer's extensive research included interviewing office workers, attending conferences, exploring new ways of using flash, reading sociological texts, reading business magazines, and looking at past representations of office life.

0.2

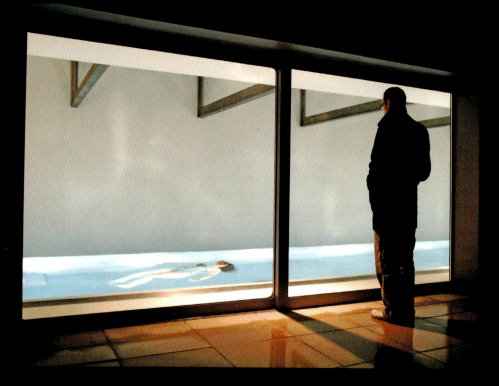

1.1

**Title: Vantage Point 1**

Photographer: Ellie Davies

This image, set in a private home, is part of a series that explores the psychological relationship between individuals and the space they occupy. Ellie Davies creates a dream-like sense of menace derived from childhood memory. Although staged, the photograph clearly relates to a possible reality; there is a sense of a story pending and as viewers we do not know how the narrative will unfold.

# 1 Planning

**All photographic series are harvested from research – from scholarly investigations to catching an overheard conversation on the bus. Researching a project is as challenging and exciting as taking the photographs, sometimes more so. It frames, informs and focuses the final photographic images. As a photographer, you need the skills and knowledge to be able to nurture the seed of an idea.**

Ideas do not exist in a void – nothing is absolutely new. You bring your own unique vision to any body of work and that vision has been informed and influenced by everything you have researched along the way. Embarking on research can feel daunting and overwhelming. Take a step back and draw up a plan or map to help you navigate the options you have ahead of you. The first stages of this plan will involve looking back and uncovering what brought you to the project in the first place. Where did the initial idea come from? Trace back the idea to your possible sources and use these as your first key areas to research. Do not self-censor or dismiss unexpected sources; include all minute details.

Did your influences derive from your own personal history – your memory? Overhearing people's conversations? Reading people's concerns in the newspaper? You may have gained an understanding of contemporary life by reading fiction or poetry, or listening to music lyrics as well as listening to the radio or reading a Facebook posting – everything has the potential to contribute to your research.

Once you have a draft research plan, you are ready to direct the vision for your work. Look for visual references and explore the medium of photography to help you translate your idea into photographs. Do not always stick to your plan, it is simply a guide; new knowledge always opens up possible new directions. Regularly update your plan to reflect what you discover on the way.

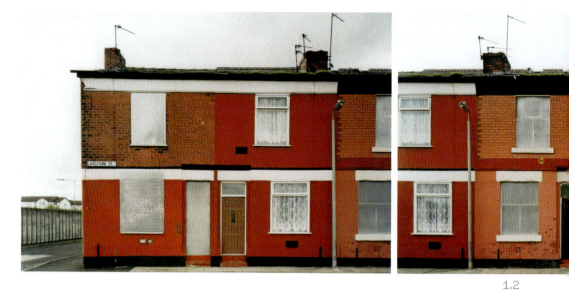

1.2

Research proposals are a key part of the research process, for students and professional photographers alike. Developing a basic research proposal will benefit the structure of any project and the way you go about making it happen. More advanced proposals can be used to apply for funding for particular projects, so being able to produce a successful proposal is a key skill for all photographers.

By breaking a proposal down into the following sections you can write clearly and make appropriate points in relevant places. You can refer back to your proposal during the working process and amend it when necessary; a proposal is a plan and needs to be updated regularly as things change.

## The title

Simple as it may seem, a title is vital and reveals more about a project than you may imagine. You may want to include a subtitle to give a little more information about the project, and you may also write a short summary of the work to be undertaken.

Start with a working title. It could be quite simple, and then continue beneath your title with a straightforward subtitle that clarifies what you are doing. You may change your title three or four times during the research process as you search for the most appropriate one.

Developing a basic research proposal will benefit the structure of any project and the way you go about making it happen.

1.2

**Title: *from* 'Nummianus'**

Photographer: Steffi Klenz

'Nummianus' is a body of work that looks critically at the displacement of people through the decline in the housing market. Steffi Klenz photographed boarded up, terraced houses in order to comment on the plight of people experiencing severe economic change. The title of the series is from a Latin inscription found in the remains of a house in the destroyed city of Pompeii. Klenz uses this title deliberately to emphasize the sense of loss and disaster experienced by the community.

## The topic or theme

The subject, topic or theme is the most significant part of your proposal; it will contain all the key details of the project. You do not need to write a long, essay-like piece, rather, you should try to get as much information as possible in two to three paragraphs. The writing should be positive and convey your sense of interest and enthusiasm about the idea. Most importantly, you need to clearly explain what it is you intend to do – giving as much relevant information as possible about the subject, how you will approach making the photographs, and how you expect the project to develop.

## Who is your audience?

Your proposal should discuss the context and audience of your proposed work – consider where you would like your finished work to exist in the world. Is it an exhibition? A publication? A public artwork? A picture essay to be published in a magazine or something else entirely? To do this effectively, you need to consider how each context might give the work a different meaning.

Thinking and reading about how photographs are read and consumed in the world will help you make decisions about the context for your own work. Next time you see a body of photographic work in a public arena, try imagining it transferred to a different context. How would it fit in? Would the meaning of the work be altered if it existed in a new context?

1.3

**Title: Emergency Briefing Room (digitally censored photograph)** *from* **'The Last Things'**

Photographer: David Moore

David Moore's series, 'The Last Things', documents a top-secret secure military location below ground in central London. It is the space that will be used as the first port of call in any situation where the safety of the country is under threat. The Ministry of Defence allowed David Moore an unprecedented level of access, enabling him to observe a live working space that is continuously on standby and fully prepared for the most extreme national emergency. Moore was able to make this work by negotiating access and having a strong proposal.

1.3

## Approach and methods

A proposal should detail your approach to making the work and the different practical methods you will explore during the project. This can simply be a list of the types of film, camera, lighting and processing that you might use. It could also be more of a discussion around technical issues and how they relate to the meaning of the project, as well as how you might produce the final work. These predominantly technical aspects of the project should be appropriate and show that you are interested in the medium and the possibilities for experimentation. How you choose to finish the work should reflect an understanding of the context it will go into or appear in.

This section of your proposal must also detail the ways in which you intend to conduct your related research. You may also want to explore the possibility of a collaboration and explain this as part of your methodology for practice. Explain why you intend to collaborate, what collaborations you have researched and the impact this way of working would have on your project.

Photography can be a vehicle to help you step into new environments and new fields. When drawing from an unfamiliar arena, you could decide to collaborate with someone from the field of interest in order to gain vital support and specialist knowledge. Making work with someone from another area of expertise can aid the creative process, making it a fruitful and enriching experience. However, when working with another person, issues of time management and division of tasks need to be well planned. Co-writing a proposal with a collaborator can help to crystallize your idea; it enables both partners to be clear about the aims of the project from the start.

## Getting in

You may want to gain access to a location or organization as part of your project and your written proposal will be key in doing this. Seeking permission to photograph is one aspect of both documentary and location photography that needs to be considered in the proposal. Laws governing who and when you can photograph differ from country to country and you should always be sure that you understand the law before attempting to take photographs in public or private spaces. The parts of your proposal that describe your subject, and also the context you are placing the work into, will be the most relevant to an organization or individual that you need to gain permission from. It is also essential to be able to clearly communicate these aspects of the proposal in emails, telephone conversations and at meetings.

**1.4**

**Title:** *from* **'A Suicide Constellation'**

Artist: Pedro Vicente

Pedro Vicente made these photograms in a darkroom by flashing an enlarger light over his head and adding patterns to each image before it was developed. He collaborated with psychology student Carol Davies to interpret the photograms using the Rorschach psychodiagnostic test, which analyses how people respond to certain patterns, and wrote down his responses to each image. Vicente then brought the work together as an artist's book, with the images shown alongside the writing they inspired.

Making work with someone from another area of expertise can aid the creative process, making it a fruitful and enriching experience.

## Proposals for funding

When creating a more advanced research proposal to apply for funding for a body of work, there are additional considerations to take into account. Potential sources of funding include government art bodies, private funders, grant-giving bodies and trusts, awards and commercial sponsors or partners. Each one will have a different application form and you must think carefully about the specific headings or questions on it. You must take your idea and your initial research findings and tailor them into a proposal for the funding organization in question.

Some funders ask for a written proposal only, others may request visual examples of your work. Think carefully and objectively when selecting images to submit with a proposal for funding. Do the chosen images portray a coherent vision, a clear story, as well as aesthetic and technical competency? Remember that 'less is more'. Keep the edit strong and concise.

If you are asked to write a project summary, bear in mind this is likely to be used in some form of publicity for the project. With the increasing use of social media, it is worth considering how your summary would work on platforms such as Twitter, Facebook or on blogs. A summary needs to be very upbeat and make the reader want to know more about the project. It is often possible to find other project summaries on websites or by calling the funding body to see if they can direct you to examples.

## Timetable and budget

These two elements of a proposal for funding are straightforward and vital: whoever the proposal is directed at will need to know if the project is feasible. A timetable and a budget are a basic version of a business plan. They may seem almost too obvious to write down, but remember that the person or people who will read the proposal are unlikely to know much about you. They need evidence that you have the ability to sensibly plan a project, both in terms of the time and money that is available. A project has to be achievable within its budget and its time line.

## Proposed research references

A list of potential references (and where you might go to investigate them) helps the proposal reader to understand the scope or ambition of the proposed project. The list should include references to photographers and artists whose work relates to the project; research sources relating to the subject or theme; links to where you might research working methods and any other related information. It may include references to fiction, music, and film, as well as theoretical debate.

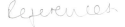
References

1.5

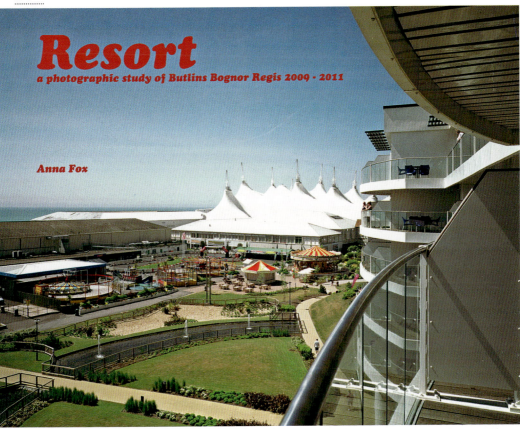

# Resort
### *a photographic study of Butlins Bognor Regis 2009 - 2011*

*Anna Fox*

1.5

**Title: Cover page insert for project 'RESORT'**

Photographer: Anna Fox

This image is a working title page for a newly commissioned project documenting the contemporary face of the holiday camp Butlins in Bognor Regis, UK. It is a simple overview of the place (Butlins) and will most likely be used as an inside cover image. However, as funding had to be raised for the project, this image with its title has been used in a proposal on the introductory page. The typeface style and colour have been used deliberately to reflect the Butlins style and to bring out the red in the photograph.

There are numerous debates and arguments about the way history is recorded and retold. Inevitably, important elements get missed out and, in the case of photographic history, whole countries have been neglected. It can be a challenging and exciting part of any research project if new historical material is discovered, perhaps in an archive or in a personal interview previously unseen or unheard. Histories of photography are frequently divided by country or continent and, undoubtedly, the histories of North American and northern European photography tend to dominate the field. North America was fast to embrace and promote photography as an art form and northern Europe was not too far behind.

## Understanding histories

Today, writers, editors and curators are expanding their research parameters. Through the growth of various diasporas, knowledge about photography and its histories is becoming a global subject. Histories of photography link photographers together and frequently propose ideas about how things are connected within a particular narrative. As a researcher, it is your job to first read, understand and then interrogate the histories presented to you. Try reading a few different books that examine photography from the same continent – this is particularly interesting as you will start to gain a sense of how the personality of the author has shaped their story.

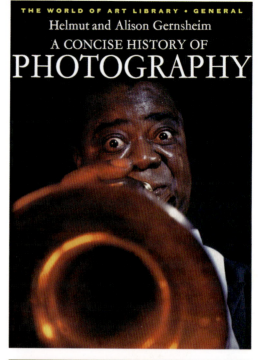

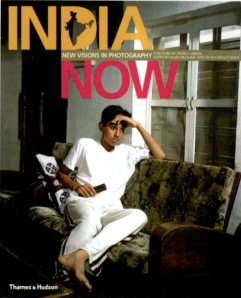

1.6

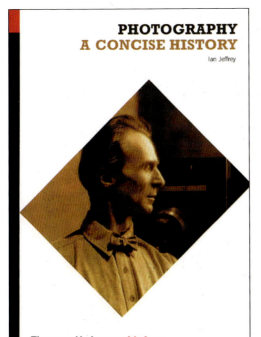

1.6

**Title: Photography history books**

Source: Thames and Hudson

There are numerous histories of photography. It is always interesting, as part of the research process, to research the author of each book you are reading and discover their history. Learning about an author's history can reveal much about the way a book has been written and edited.

## Further information

Once you have found photographers that interest you, or a period of photographic history that is intriguing, make a note of the details and search other publications and the Internet for further leads and information. If the photographer is living, their own website should be a resource worth exploring. Their résumé, albeit a list with no commentary, will tell you more about their history. Obituaries are also interesting and will give you a short overview of a photographer's life and work; you may need to visit a newspaper archive to find past examples.

Looking at historical examples and research enables you to think about why a body of work was made and the relevance of its context from a distance – time being the distance. Histories inform you of how things happened and why. It is often revealing to investigate the political and social histories of the period alongside that of the photographers; this will give you more understanding of why things happened when they did.

Research into the practice of other photographers or into a particular subject or theme can reveal a huge volume of material, particularly if carried out on the Internet. When undertaking this type of research, you will need to refine your results by looking at information about the photographers and subjects in closer detail. You can do this by researching a photographer's history via their own website, looking at their projects and résumé, and by searching other websites, such as Wikipedia. From this you will gain a basic overview of the status of the photographer and can gauge whether they are still relevant to your research list.

## Refining your results

Once you have narrowed down your initial search results, you can look in more detail at relevant photography exhibitions, magazines and agencies. You should check the history of each organization and find out who they are, what they do, how recognized they are and in what context they operate. Amazon, Abe Books and other Internet booksellers that sell second-hand material can be a useful source of information about museum and gallery publications.

You need to keep in mind that the Internet is not always the most reliable resource for research. Ultimately, you need to attend talks and lectures, listen to radio and television programmes and go to exhibitions to find out about photographers and their work. Always carry a notebook and pen or a way of recording information; a small camera is often useful to record book covers you might see in shops or markets.

## Magazines

Photography magazines are a rich source of photographers' work. There are numerous magazines published around the world that might help you with your research. If your local library does not stock a particular magazine, you could put in a request for them to do so. Magazines such as *Photoworks* (UK); *Aperture* (US); *Exit* (Spain); *Camerawork Delhi* (India) and *Estonia* will all give you the opportunity to look at the work of emerging photographers alongside more established practitioners.

### Read widely

Refresh your thinking about photography by engaging with a broad range of written materials. If you find a piece of writing difficult, move on to the next essay or book; you can go back to the more complex pieces later. Re-reading texts at different points in time encourages new ways of seeing the world and of seeing photography. A broad-minded approach to selecting your reading material will keep you informed and inspired.

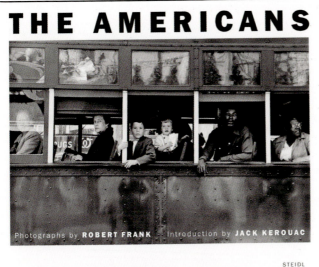

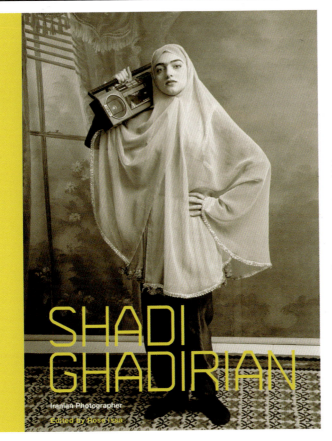

1.7

**Title: The Americans**

Source / Photographer:
Steidl/Robert Frank

Photographers often have their work published in monographs. Swiss photographer Robert Frank travelled the United States in the 1950s, documenting the American people from the point of view of an outsider. He teamed up with renowned Beat writer Jack Kerouac who provided the text for this monograph.

1.7

1.8

1.8

**Title: Shadi Ghadirian: Iranian Photographer**

Source: Rose Issa Projects/
Saqi Books

Shadi Ghadirian is a female Iranian photographer whose work looks at the paradoxes faced by Iranian women. The 'Qajar' series, shot in the late 1990s and featured in this monograph, juxtaposes historical backgrounds and clothes with elements of the modern day.

The development and writing of theory, like history, grows out of a research process. Theorists bring ideas and concepts together in a way that is often surprising; they look at the world from various perspectives, sometimes based on theoretical thinking from different disciplines. A theorist can shed new light on familiar aspects of daily life and question conventional or traditional ways of thinking. Reading theory can be more challenging than reading history – some of the ideas are unfamiliar and complex, so you need time to make sense of them. Try breaking up theoretical reading; read a chapter that interests you, then allow yourself thinking time to reflect on what has been said. Keeping notes may help you.

## Photographic theory

Certain theoretical models established in fields outside photography, such as linguistics or psychoanalysis, have been applied to photography by theorists. As with the history of photography, there is a predominance of theoretical writing on photography by North American and European writers. This is an inevitable result of the academicization of photography in higher education since the 1960s in the US and Europe. As photography education spreads further afield internationally, this will change. It is also interesting to research cultural or media theory alongside photographic theory to gain another point of view.

## Photographic journals

Journals on photography are relatively recent phenomena. In the UK alone, there are several journals dedicated specifically to photography. A journal publishes essays and papers that have usually been peer reviewed. This means that a panel of experts has commented on the text and the writer or editor then edits it accordingly, before publication. Journals are published frequently and so promote the most contemporary views of theorists around the world. Your local library may subscribe to an online or paper copy of a journal, and it is a resource well worth exploring.

## Books

Theory books discuss photography from a critical perspective, often analysing its construction and content from radical positions. This kind of writing often turns familiar concepts upside down and may challenge your vision as a photographer. This is useful in terms of refreshing your thinking and questioning accepted attitudes to the world you are recording or representing.

A photographer has a certain responsibility in terms of how they choose to represent the world, so being informed by theoretical opinion can enable fresh thinking on this. Theoretical concepts can be applied to practice and through this, theoretical ideas can be explored as part of the practical research process.

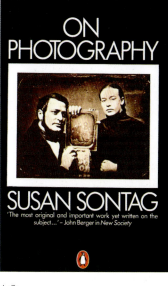

1.9

1.9

**Title: Photography journals and theory books**

Source:
Bloomsbury/Penguin/Routledge

Journals predominantly publish theoretical texts with some images as reference. *Photography & Culture* is one such journal, releasing three issues per year since it was set up in 2008.

Susan Sontag's *On Photography* is seen as a seminal theoretical book on photography.

*Photography: A Critical Introduction* is a theory book that looks at key debates in photographic theory and practice.

1.10

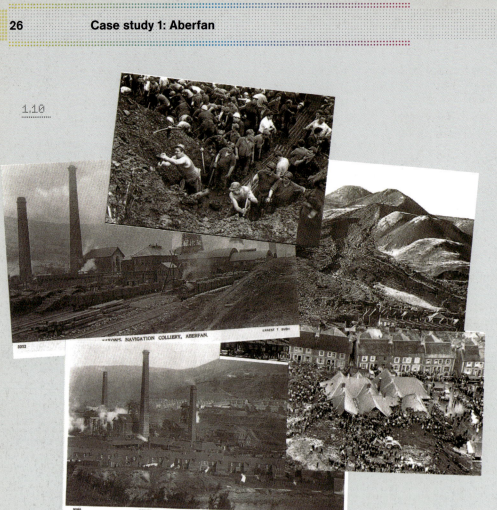

1.10 – 1.11

**Title: *from* 'Aberfan'**

Photographer:
Natasha Caruana

Caruana created new images
using archive material, combining
narratives of past and present.

1.11

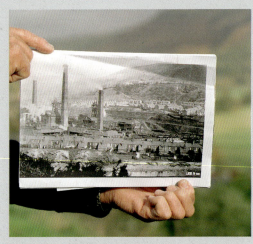

# Case study 1
# Aberfan

Natasha Caruana's project, 'Aberfan', illustrates how research can lead you down new and exciting paths. Working within the documentary genre, Caruana captures the modern life of a distinctive post-industrial village.

Before approaching members of the community, it was important to understand the past and present history of the village of Aberfan in Wales. Caruana used the local archive housed at Merthyr Tydfil's Central Library to gain insight into historical depictions of the village, and the local newspaper to uncover knowledge about the village in the present day. Both resources were inexpensive, accessible and offered an insider's point of view.

Aberfan was once a thriving Welsh coal mining village. For decades the mining waste was deposited on the hillside above the village, forming a 'slag-heap'. One autumn day, torrential rain caused the heap to collapse and thunder down the hillside into the village, engulfing all that stood in its path. A total of 144 people were killed, including 116 children at the primary school.

The tragic history of this village, revealed through research, informed Caruana's point of view. Taking a personal approach to the project, she met members of the community and recorded their stories, giving her project an informed perspective. Carrying copies of archive images, Caruana stopped people on Aberfan's main street. She asked them to hold the images for her to photograph, which allowed her to create a series of intriguing documents.

Through this process she was able to organize access to homes and community centres, creating opportunities for more intimate dialogue with village members. Caruana met numerous individuals and recorded their life stories and experiences of the disaster and pit closure. With this information she created a primary resource archive for the project.

Having researched the history of the miners' strike and pit closures, Caruana was able to enter into conversations with the retired miners. This helped her to earn their trust and gain access to private spaces within the community, such as the Working Men's Club, to which women had restricted access.

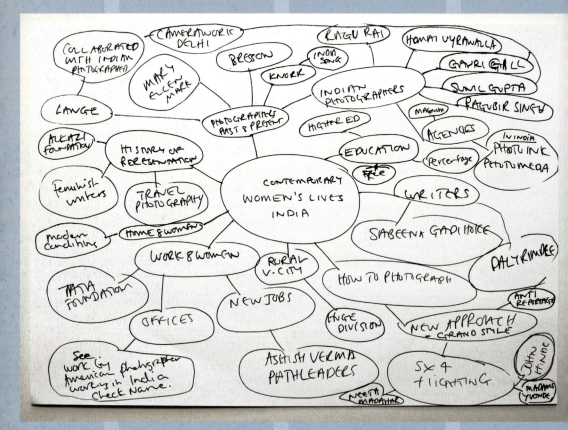

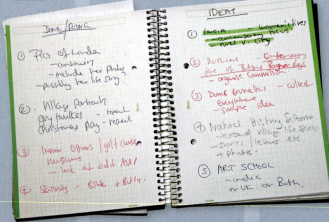

1.12 – 1.13

**Title: Mind map and photographer's notebook**

Source: Anna Fox

These images illustrate different ways of recording ideas. The circular, web-like structure of the mind map contrasts with the linear list used in this photographer's notebook. Both are valid ways of recording your ideas – try each method and see what you find most useful.

# Activity 1
# Recording ideas

Ideas are fragile and have a habit of materializing anytime, anywhere. Without a means to record and preserve them, they are liable to vanish from the imagination as abruptly as they appeared.

It is important to find a system of documenting your ideas at the moment of conception. This could mean having a notebook or sketchbook with you at all times. For the more digitally inclined, your mobile phone can function as a Dictaphone to record sound or voice memos on location. You can use the camera on your phone to photograph key inspirations, locations, exhibitions, characters – anything that acts as visual reminder for your idea. You could even send yourself an email or text message when the idea occurs.

## Notebook project

Keep a notebook with you at all times. Populate it with every creative thought surrounding your projects and your photographic practice. This means that even though some things might sit on the back burner for a while, you still have a concrete documentation of your ideas for future reference. The notebook or ideas book can also be used to trace your work back to its origins.

## Mind map project

A mind map allows you to think about an idea from a number of perspectives; it is a visual diagram, branching out from a central theme or topic. It has the potential to connect research possibilities in a new way through its web-like structure. A mind map is circular rather than linear, like a list, and can shed a different light on the scope of your idea. It helps you draw on previous knowledge.

As you create mind maps, you may find that using larger sheets of paper enables a more 'helicopter' view of your project, giving more space for notes and links. You could also incorporate images, clippings and photographs.

Looking at your mind maps, which idea now seems the most interesting? Which idea is most feasible? You may need to make separate mind maps to explore the feasibility of each idea.

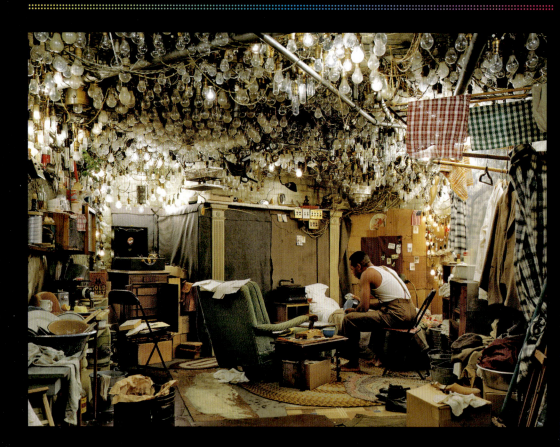

2.1

2.1

**Title: After 'Invisible Man' by Ralph Ellison, The Prologue**

Artist: Jeff Wall

Photographic works can be inspired by researching other creative genres, such as film, literature and theatre. Ralph Ellison's 1952 novel *Invisible Man* inspired this Jeff Wall image. The novel centres on an unnamed African American man who falls into a forgotten room in the basement of a large apartment building during a riot in New York.

The man's social invisibility is symbolically highlighted by his increasing collection of illegally-powered light bulbs. In a painstaking production using exactly 1,369 light bulbs, as described in the text, Jeff Wall depicts the narrative through the construction of a large-scale photograph.

# 2 Developing ideas through research

**Artists and photographers throughout history have searched for references in libraries, museums and archives. Many contemporary photographers have huge personal archives of their own that may include books, photographs, objects, magazines and more. These photographers will use their archives regularly to investigate an idea or contemplate a new direction.**

Today, many emerging photographers and writers depend on gathering a large percentage of their research on the World Wide Web. The Web has democratized knowledge in a way that was previously unimaginable. However, before you dedicate yourself to days in front of your computer screen, take a moment to consider the value of getting out in the world: going into places that contain important research materials; discovering archives that you had not known before; going to talks, events and conferences that may introduce you to new ways of looking at the world. The Web provides us with a broad starting point, but you need to be aware that the material you find there may also have its limitations and, in some cases, may be far from correct. The concept of 'truth' or what is 'real' is a difficult one; no research source is infallible. Even if you meet an admired photographer and discuss their work, they may not be able to, or want to, give you the full picture of the story behind the scenes. You need to bring a level of your own interpretation and critical reflection to what you find.

Photography comes in a huge number of different forms. It is used to record our families and places we visit on holiday; to promote products, companies and clothing; to report on news stories and to illustrate books and magazines. It is also used by artists and photographers to create stories and artworks. All aspects of photography are fascinating; so as a researcher in photography it is wise to investigate all the places where photographs exist in the world.

## The library

Libraries are extraordinary places; they have many different types of resources, from books to databases, slide libraries, digital archives, sound archives, special collections, journals and magazines. There are many types of library and some specialize in particular subject areas. Clearly, a library will contain books, but what may not be immediately evident are the special collections or archives that exist behind its walls — some libraries have significant collections of photographs.

The British Library Sound Archive holds the Oral History of British Photography in which you can find interviews and listen to a photographer's history in their own words. You can attend courses on how to be an oral historian and how to interview people. The National Gallery of Art in the US has a collection of interviews with photographers, as well as podcasts and lectures which can be viewed online.

Photography also exists in image libraries; these banks or libraries provide 'stock' material primarily for commercial use. An image library can also be specialized. If you want to use photographs from an image library you have to pay for the privilege; this is one way that photographers make a living.

2.2

**Title: Interior, British Library**

Source / Photographer:
Alamy/B.O'Kane

The British Library has an extraordinary collection, holding 14 million books, 920,000 journal and newspaper titles, 58 million patents and 3 million sound recordings.

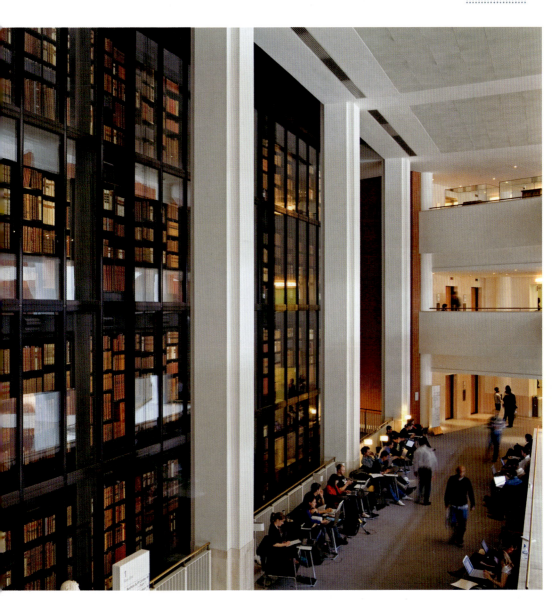

2.2

All aspects of photography are fascinating;
so as a researcher in photography it is
wise to investigate all the places
where photographs exist in the world.

## Specialist libraries

A specialist library will hold books and material concerned with a particular subject. It is a good idea to search for such a library right at the start of your research journey. The Internet can provide details of specialist libraries. For instance, the Women's Library <www.londonmet.ac.uk/thewomenslibrary/aboutthecollections/> is based at the London Metropolitan University. Their website gives a clear indication of who they are, how long they have existed, what they do and what is coming up. Simply visiting a library and going to some of their events or study days can spark new project ideas and avenues to research.

2.3

2.3

**Title: National Media Museum, Bradford, UK**

Source: National Media Museum/ SSPL

The National Media Museum (NMM) is part of the National Museum of Science and Industry. The museum first opened as the National Museum of Photography, Film & Television in Bradford, in 1983, with a remit to explore the art and science of the image and of image-making. The NMM is situated in the heart of Bradford, UNESCO City of Film, and is home to over 3.5 million items of historical significance.

Museums are committed to education and continuously run events, talks and conferences that are of great value to both the student and the professional researcher.

## Museums

Many museums, like libraries, house collections of photographs. For example, the Pitt Rivers Museum—a fascinating museum of anthropology at the University of Oxford—has collected photographs since it was founded in 1884. The collection contains important fieldwork archives, such as those of anthropologist E. E. Evans-Pritchard, as well as the photographs of travellers such as Sir Wilfred Thesiger, whose collection alone numbers some 38,000 images. The museum still collects photography and has a number of successful online research projects that use photographs.

Some art museums boast wonderful photography collections, such as the Museum of Modern Art (MoMA) in New York, which has been collecting photography since 1930. Museums dedicated to photography, such as the National Media Museum (NMM) in Bradford, UK, include displays on the history of how photography and the moving image have evolved. The NMM also has a vast archive of both artistic photography and news photography from a national newspaper, including more than 3 million images taken from 1911 to the 1960s. This type of archive provides a mine of information about the past. Newspapers all over the world have their own archives and these are well worth exploring.

Museums are committed to education and continuously run events, talks and conferences that are of great value to both the student and the professional researcher. You can often subscribe to regular email newsletters to keep you informed about particular museums. You will also find different types of experts in museums—from archivists to curators and directors. Investigate the different roles and responsibilities these people have as part of your research process.

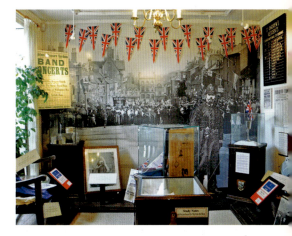

2.4

2.4

**Title: Interior, the Museum of Farnham, UK**

Source / Photographer:
The Museum of Farnham / Natasha Caruana

The Museum of Farnham is an award-winning town museum in the UK. It contains anthropological and social history materials and artifacts. The displays in the museum change regularly and the museum's archive is open for public access.

## Galleries

Galleries exhibit photographic work that is considered to have artistic or historical merit and, in the case of commercial galleries, a commercial value as well.

It is rare for a gallery to have its own collection; rather, they often exhibit a particular show or collection that has been loaned to them for a given period of time. Some gallery owners and staff may be collectors themselves and have interesting private collections that, on occasion, you may be able to access. Museum curators may borrow items from galleries when they put together major exhibitions.

In the UK, there is a history of independent photography galleries, which grew in number in the 1970s and 1980s (sadly, many have recently closed). Independent galleries help new, emerging photographers to exhibit their work alongside more established photographers. Most had, and still have, a degree of state funding to aid them to do this and part of their mission is to provide educational material through events and exhibitions aimed at the general public, photography researchers and students. Outside of the UK there are many independent galleries including the Centre for Contemporary Photography in Australia and SF Camerawork in the US.

Viewing exhibitions is an important part of the research process; going to gallery talks and events expands knowledge and understanding of the practice and processes behind the work on the wall, frequently giving insight into the life of the photographer. Gallery talks are a valuable opportunity to hear views and opinions from contemporary writers, critics and curators.

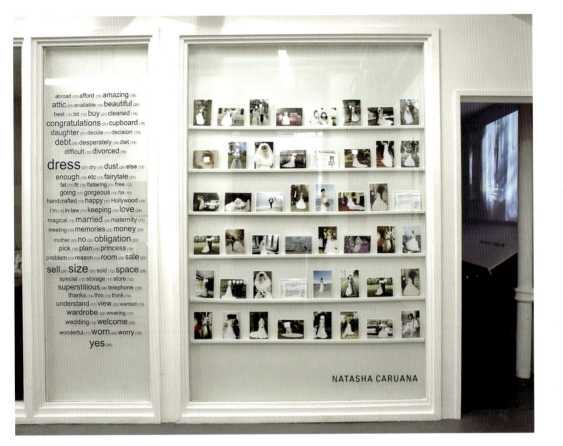

The tagcloud text reads:

abroad (10) afford (13) amazing (18)
attic (20) available (12) beautiful (20)
best (12) bit (10) buy (21) cleaned (15)
congratulations (31) cupboard (18)
daughter (27) decide (11) decision (13)
debt (30) desperately (16) diet (14)
difficult (15) divorced (18)
dress (47) dry (10) dust (20) else (12)
enough (19) etc (13) fairytale (21)
fat (11) fit (10) flattering (10) free (12)
going (17) gorgeous (16) ha (10)
handcrafted (13) happy (17) Hollywood (14)
I'm (10) in-law (11) keeping (16) love (24)
magical (13) married (24) maternity (17)
meeting (10) memories (22) money (23)
mother (10) no (20) obligation (32)
pick (16) plan (18) princess (19)
problem (13) reason (13) room (20) sale (22)
sell (20) size (30) sold (12) space (25)
special (12) storage (13) store (12)
superstitious (26) telephone (13)
thanks (14) thin (13) think (14)
understand (17) view (20) wanted (10)
wardrobe (22) wearing (10)
wedding (15) welcome (25)
wonderful (11) worn (25) worry (18)
yes (30)

NATASHA CARUANA

2.5                                                                                 2.5

**Title: Exhibition installation by Natasha Caruana**

Photographer: Phillip Reed

'Fairytale for Sale' is an installation of images and text. The images are displayed on a series of shelves and presented behind glass to create the sense of a shop window and an archive. The photographs are of brides selling their dresses on the Internet. The text next to the images is a 'tagcloud', listing all the reasons why the brides are selling their wedding dresses.

The Internet has revolutionized the distribution and access of information and services in varying degrees across the globe. For a photographer, the Internet can provide vital information in the initial stages of formulating and developing an idea. As your idea evolves from planning and preparation through to production, the Internet continues to play a critical part: from the sourcing of photographic equipment to mastering new photographic techniques and watching online tutorials, as well as practical aspects such as checking opening times of libraries and making travel arrangements. Internet resources can also be used in direct relation to the photographic project. For instance, a landscape or street photographer could use Google Maps and Google Street View to determine possible locations.

**Bookmarking and search engines**

If you find a useful website and want to revisit it at a later date, add it to your browser's bookmarks or favourites directory. Creating bookmarks of frequently visited websites saves you time and prevents you from forgetting potentially useful sources. Organizing your bookmarks will make your time on the Web more efficient and, over time, will create a digitized personal research directory. It is vital to be as organized as possible and to make sure that you have archived the material you need in a way that makes it easy to retrieve.

A search engine such as Google will enable you to find research locations as well as images. Web links are also useful – each site you visit may have a list of links to other related sites.

The Internet has revolutionized the distribution and access of information and services in varying degrees across the globe. For a photographer, the Internet can provide vital information in the initial stages of formulating and developing an idea.

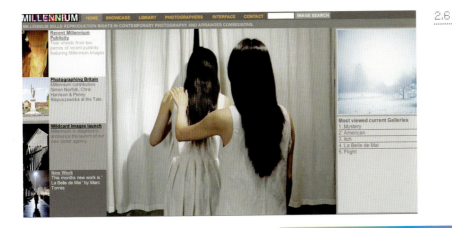

2.6

**Title: Millennium Images**

Source / Photographer:
Millennium Images/
Lisa Johansson

Online picture libraries are a
valuable Internet resource, allowing
you to view thousands of images,
searching by theme, photographer
or keyword. Each library holds
images by the photographers they
have chosen to represent. They sell
reproduction rights to the images
they hold and arrange commission
for their photographers.

## Internet research

Organization is the key to keeping your
Internet research in order.

Compile lists of websites that interest you
and add them to your Internet browser's
bookmarks or favourites directory.

Alternatively, you could use an online
bookmark manager. These have the
benefit of being accessible from more
than one computer and may allow you
to share your bookmarks directly with
friends and peers. There are many online
bookmark managers to choose from,
each with different features.

Once you have decided how you would
like to manage your bookmarks and have
started compiling them, refresh your
memory by returning to bookmarked
pages regularly and keeping notes on
important points you want to remember.

Share information about interesting pages
through your blog or social networking
site – the perspectives of your friends
and peers are valuable. They may also be
able to share links to sites that could be
of interest to you.

## Blogging

Blogging is a very useful tool for documenting research and, for that reason, it is inspiring and insightful to read other practitioners' blogs. It is an accessible way of gaining further information that can be harnessed to nurture your own ideas.

Magazines, galleries, agents and individual photographers are all increasingly keeping blogs. By assessing these blogs, you can gain insight into a particular photographer's creative process, get updates from behind the scenes of an exhibition or read about forthcoming features that will be in the next edition of a magazine.

A convenient method of keeping abreast of a multitude of blogs is by using an 'RSS' (Really Simple Syndication) reader such as Google Reader. RSS readers allow you to access all of your blogs from one page. The blog entries will be posted in the form of a list, making it easy to see the latest updates quickly.

As a photographer, you can blog throughout your project using text, images, videos, audio and Web links to relevant and inspiring sites. This will drive online traffic to your own website, as well as evolve to become an accessible, online multimedia archive of your project. Blogging will also allow you to publish content that may otherwise not be possible within the limitations of an exhibition, book or press article. Chapter 4 looks in more detail at blogs as a valuable means of compiling your research, on page 112.

## Social media

Social media networking is a relatively new but increasingly widely used way of communicating and sharing information. Sites such as Facebook and Twitter provide users with simple tools to create a custom profile using text and pictures, and they can be a valuable tool for photographers.

A photographer can use social media in a number of ways: as a basic self-promotion tool or as a more advanced and interactive platform to engage in online dialogue with their followers and the wider photographic online community. This powerful, direct dialogue between image creator and audience allows both parties to bypass the traditional media outlets of print journalism, TV and radio. As such, social media can present students and photographers with a new avenue for researching the work of other practitioners. You can use social networking sites to ask questions and help find answers to otherwise difficult research questions. You can also share your research and findings.

The use of social media can raise issues of privacy. If you decide to use social media to start creating a fan base, it's worth setting up separate Facebook or Twitter accounts for your professsional and personal profiles. This way you can keep your photographic and project material separate from personal exchanges and information.

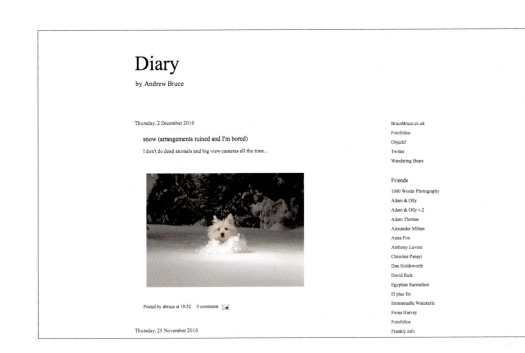

# Diary

by Andrew Bruce

Thursday, 2 December 2010

snow (arrangements ruined and I'm bored)

I don't do dead animals and big view cameras all the time...

Posted by abruce at 18:52    0 comments

Thursday, 25 November 2010

BruceBruce.co.uk
Fotofolios
Objectif
Twitter
Wandering Bears

Friends
1000 Words Photography
Adam & Olly
Adam & Olly v.2
Adam Thomas
Alexander Milnes
Anna Fox
Anthony Luvera
Christina Panayi
Dan Holdsworth
David Rule
Egyptian Surrealism
El plus En
Emmanuelle Waeckerle
Fiona Harvey
Fotofolios
Frankly.info

2.7

2.7

**Title: Diary by Andrew Bruce**

Source:
<www.abruce-images.blogspot.
com>

This screengrab shows an example of a blog becoming a digital research page. Bruce uploads information found on the Internet for others to have access to references, but also for him to keep a record of his own research.

It is inspiring and insightful to read other practitioners' blogs. It is an accessible way of gaining further information that can be harnessed to nurture your own ideas.

Archives are everywhere and vary hugely in scale and content. They can be any of the following: a small-scale personal archive that we keep ourselves; a large, historically significant museum archive; the archive of a company, institution, or newspaper; or the archive of an individual photographer. Photographic archives may contain more than just prints. For example, the National Media Museum in the UK also holds photographers' diaries and letters, and the Getty Research Institute in the US has collections of letters, sketchbooks and albums. Some organizations and museums keep quite general archives, while others are far more specialized: some may be dedicated to a particular subject, period or place, and others to the work of an individual photographer. The history of how an archive has been collected is often as interesting as the material it contains; if there is no published material about this history you may want to interview the curator.

## Accessing archives

To gain access to an archive you will need to book an appointment in advance. Many archives are busy places where researchers go on a regular basis to look at photographs and other related materials close-up. Seeing a physical print – often made by the photographer themselves – is a very different experience to seeing the image reproduced on the page of a book or on the Web. Detail, focus, colour and tone in a photographic print can often be quite different to the reproduced versions, and it is always interesting to see the scale that the photographer chose to make the print. You may get the opportunity to talk to one of the specialists in the archive you visit, which is also an enlightening experience.

2.8

2.8

**Title: Inside the V&A Print Room**

Photographer: Anna Fox

The Victoria and Albert Museum in London has a fantastic archive of art-based photography. You can visit as a student group or as an individual and book in advance the material you are interested in viewing. Great care has to be taken when handling precious original materials; gloves may need to be worn and notes can only be written in pencil.

2.9

**Title: Landmark—European Tour**

**Photographer: Anonymous/**
**Yuri Gomi**

Yuri Gomi, a Japanese photographer
based in the UK, is working on
a project to reinterpret her own
family photographs. Her great-
grandmother and a friend made a
European tour in 1966 and asked
passers-by to record them outside
various significant monuments
as a document of their trip. Yuri
is visiting the same monuments
and creating self-portraits at these
locations. This work reflects on the
differences and similarities between
past and present in relation to
social and cultural behaviour. The
juxtaposition of the two images
gives the work a humorous tone.

2.9

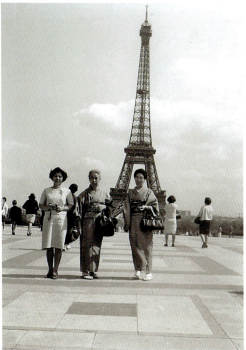

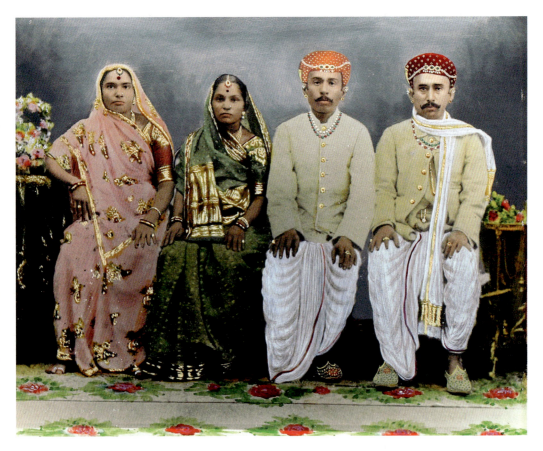

2.10

2.10

**Title: Family portrait, gelatin silver print and oil painting, c.1920–1940**

Source: The Alkazi Collection of Photography

The Alkazi Foundation for the Arts has been collecting 19th- and 20th-century photography of South and South East Asia for over 30 years. Painted photographs such as this are one part of the archived collection. The foundation encourages scholarly research in its archives that also include architectural, anthropological, topological and archaeological photographs. They have published a number of important books from this research.

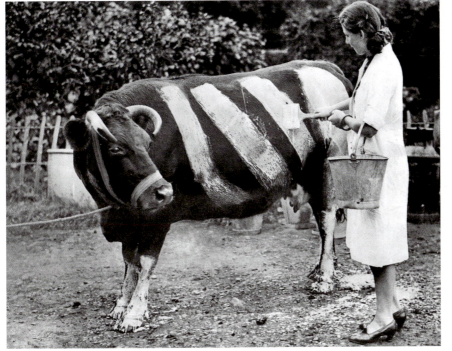

2.11

## History

An archive can give you an insight into past and present both in relation to the history of photography and the social and economic history of a given time or place. Discovering a collection that has been hidden is an exciting business. It takes time to order and archive such a find and the process reveals new knowledge. Photography and the Archive Research Centre, based at the London College of Communication, employs researchers who explore the idea of archives both through the creation of new work and through the investigation of the past. A number of archives have now been digitized and links to them can be found on the Internet. The Internet has become a valuable and accessible way to connect researchers to archives around the globe, some well known and some only recently uncovered.

2.11

**Title: Painted Cow, World War II**

Source: Alpha Press

Many museums have historical photographic collections specific to their subject of interest. This image shows a cow being painted to make it more visible to pedestrians and motorists during the blackouts of World War II.

## Vernacular photography

There are various interpretations of what is or isn't vernacular photography. The most common perception is that vernacular photography is photography of the everyday: snapshots; wedding photography; industrial photography; high-street studio photography; train and plane spotters' photographs, and so on. One of the wonderful things about photography is the fact that you can find it in so many different places; it is the most democratic medium in the sense that it is everywhere and almost everyone has access to use it. This is what makes vernacular photography such a fascinating and valuable research tool.

Artists and photographers use vernacular photography in different ways. Some will use it simply as part of the research process – as a reference, to inform a way of working or as part of investigating a subject area. Others may use vernacular images as part of their finished work.

Looking at vernacular photography from the past is a vital part of historical research; curators and photographers may use this type of photography as part of the narrative of an historical exhibition. Curators Val Williams and Susan Bright used vernacular photography from cookery books, picture postcards and family albums alongside the work of well-known photographers, such as Martin Parr and Paul Graham, in the exhibition *How We Are: Photographing Britain, from 1840s to the Present* at the Tate Britain in 2007. It created an extraordinary picture of how Britain has been represented in photographs.

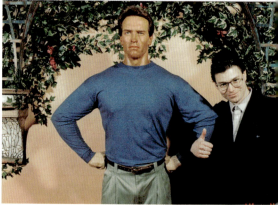

2.12

2.12

**Title: *from 'Waxworks'***

**Artist: Stephen Bull**

Stephen Bull has been working with found photographs since the early 1990s. He is fascinated by how photography is used in popular culture. 'Waxworks' is compiled from hundreds of unsold photographs from the photography shop at tourist attraction Madame Tussauds, in London. The series, usually exhibited in a large-scale grid, reveals the different reactions to the model of Arnold Schwarzenegger and to the camera, and perhaps represents what is and what is not meant to be shown in such souvenir photographs.

2.13

2.13

**Title: Bilder von der Straße No. 832, Berlin, April 2004**

Artist: Joachim Schmid

Artist Joachim Schmid has been collecting waste photographs for over 15 years. The work has evolved into several different series including 'Pictures from the Street' and 'The Photographic Garbage Survey Project'. Schmid collects and preserves thrown away or waste photographs, systematically archiving them for future use.

The result of his collections and travels is a report for each city consisting of the found photographs, a list of discovery sites, maps with the inspected streets marked, and a statistical evaluation. Altogether these reports form an international compendium of photographic pollution in modern cities.

Being an active researcher means doing more than simply sitting in front of a computer – you need to find out what is happening around you and get involved with different activities that could have research potential. A starting point might be to investigate local galleries and museums to find out if they host lectures, artists' talks and workshops. You may also decide that you want to take your research further and conduct your own interviews.

**Lectures**

Attending a lecture, whether in an educational institution or another venue, is a great way to research a topic; they offer a concise and self-contained means to gather knowledge. The manner in which information is delivered—in a lecture, by a live speaker —cannot be replicated by any other means, and you get to put a face to the expert's name.

Within educational institutions, lectures take the form of a series of presentations given by a professor or lecturer on a particular topic. Lectures are not normally interrupted for questions, but will often be followed by either panel discussions or question-and-answer sessions. Within these forums, the audience is in the privileged position of being able to question the experts directly.

If you cannot attend a lecture in person, enquire whether the lecture is streamed online or made available later for podcast or download.

Take note of how professional interviewers work – you need to allow your subject ample time to speak. To be a good interviewer, you need to be a good listener.

## Tips for interviewing

- Make sure you choose a comfortable, appropriate venue.
- Prepare your questions in advance, after conducting relevant research.
- You may want to email your questions to your interviewee in advance so they can prepare.
- Ideally you should record the interview, but check your interviewee is happy for you to do this first.
- Ensure any recording equipment is in working order before you start, and make sure you have sufficient supplies of stationery to take notes.
- If you do record the interview, transcribe it soon afterwards while the impression of the interview is still fresh in your mind.
- Give the interviewee plenty of time to answer – don't feel tempted to fill any pauses with other questions; give them time to think.
- Be prepared to ask follow-up questions.

## Interviews

Interviews are an invaluable way of gaining primary research material. Meeting photographers, editors, curators and any other professionals involved with photography is an excellent way of finding out what they have done, when and why. Interviewing people is a huge privilege and often quite difficult to arrange. If you do get an opportunity like this, you need to prepare well; make sure your questions are designed around your area of interest, but also allow space for your interviewee to tell you other things that they may feel are relevant. Take note of how professional interviewers work — you need to allow your subject ample time to speak. To be a good interviewer, you need to be a good listener.

## Reading

Reading is a solitary act and allows you to work independently to obtain background information in your own time. The effort invested in reading around your subject matter can pay dividends in a number of ways: the discovery of a pertinent quote, historical fact or statistical figure to bolster your proposal; or the finding of a potential collaborative partner in the form of an author, artist or expert. The more you read around your idea the more informed you will be to promote it to financiers, the press, galleries, curators and, importantly, to discuss it in peer reviews.

## Listening

Having gained a wealth of knowledge in the course of your investigations, you can present your ideas and thought processes to others and invite their feedback. To get the most from this, you need one key skill: being a good listener. Presenting your work, often to strangers, can make you feel vulnerable and defensive. Listening is an active, not passive, task.

Listen to how others react to your work and consider whether it speaks for itself. Learn to pick up on key words and phrases that are used to describe your work. Ask for clarification if you need to, and don't be afraid to seek further explanation. While discussing your work do they make reference to other artists or texts? If so, take note of them.

Be open to feedback. You may receive comments that you expect and welcome. Equally, you may receive some comments that are unexpected or you feel are inaccurate or unwarranted. Always bear in mind that the dialogue centres around the work; try to judge the strengths and weaknesses of your own project as you would judge the work of other artists.

Your listening skills will develop and improve each time you undertake an exercise such as this. Take the time to write up the feedback you heard after the event. How much do you remember? What are the key points to follow up on?

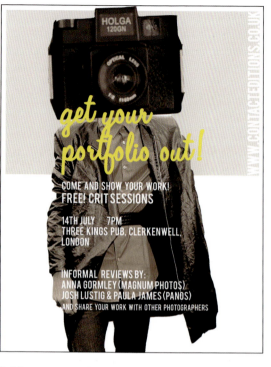

2.14

2.14

**Title: Get your portfolio out**

Source: Contact Editions

This is an advertisement for one of Contact Editions' bi-monthly review sessions in London. These sessions provide photographers with a forum for discussing their work with professionals and members of the public in an informal setting.

## Reviewing

You need to allow time to review your project on an ongoing basis; don't feel that a review is only done with a completed body of work. Having your progress reviewed is a rich and rewarding process.

There are many means to have progress reviews during the development of a project, such as making time with peers and taking it in turns to review each other's work. Alternatively, many institutions and independent photographic organizations offer advice-led reviews, such as Contact Editions, which offers bi-monthly informal reviews in London. During these reviews, up to three photographers are invited to present their work and a key photographic professional is also present to offer their feedback. The nature of these informal reviews allows for the majority of the evening to be social time, in which the Contact Editions team encourage members of the audience to bring their work-in-progress to continue discussion amongst newly formed photography contacts. This is a great way to test out people's reactions to the project, reactions that are not biased by knowing you or your previous work. This is also an excellent way to form new relationships in the photographic world. Building a network is vital to photographers.

Alternatively, when you feel confident enough with your progress, a more formal one-to-one review can offer you in-depth tailored feedback. There are many arts organizations that offer this service – you can search the Internet to find the organizations that are local to you. You should bear in mind that reviewing is prone to subjectivity and bias; although you may have a number of reviews that inspire you, you are not always bound to agree with a reviewer's perspective. One major advantage of being reviewed face-to-face is that you learn so much about the professional world. Having your work reviewed in this way is a two-way conversation—you can follow up ideas, probe responses and investigate motives and feelings. You get a sense of how someone feels about your work in a way that would be concealed in a written response.

Having your work reviewed is a two-way conversation—you can follow up ideas, probe responses and investigate motives and feelings.

Research informs practice in many different ways. Knowledge gained through the research process will contribute to forming a photographer's approach to making work. It may be as simple as influencing a style of working or the choice of props and surroundings. It could be that background research reveals new information about a place or people. It could tell you more about a society, a way of thinking, the shape or colour of something, the history of a place — almost anything that tells a story in one way or another could be part of your research.

We have been talking about background research by looking at libraries, archives, lectures and vernacular photography. All of these can aid the understanding of a subject in terms of why it might be interesting to make photographs, as well as how to develop visual strategies for the production of photographs.

It is clear that the sources of a photographer's research will be extensive, very varied and not always explicit in the final body of work. In order for this research to form a valuable and continuing resource, it should be archived. A research archive is a rich resource, both for the photographer and for future researchers trying to discover how and why a photograph worked.

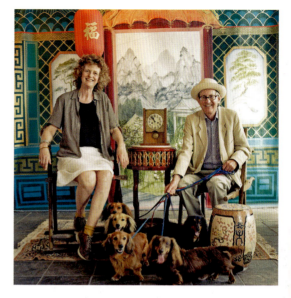

2.15

2.15

**Title: *from '21st Century Types'***

Photographer: Grace Lau

In her book *Picturing the Chinese: Early Western Photographs and Postcards of China* (2009), Grace Lau explored photographic portraits made by Westerners in China during the turbulent years between the Opium Wars and the Boxer Rebellion. Using her 30-year-old Hasselblad camera, Lau took on the role of the 'imperialist photographer', documenting her 'exotic' types in Hastings, in the UK, in order to respond to the historic situation whereby foreign photographers recorded the 'exotic' Chinese people. As a British photographer of Chinese descent, Lau's photographs reference both cultures past and present and raise interesting questions about the way culture is stamped onto us via the constructed set of the traditional high-street studio.

2.16

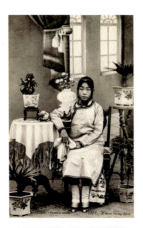

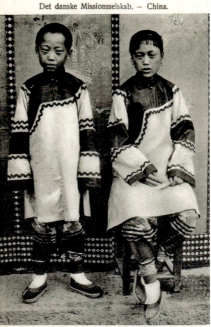

Det danske Missionsselskab. — China.

No. 62. Chineserbørn.

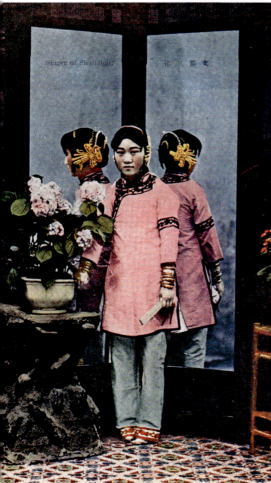

2.16

**Title: Victorian colonial photographs of China**

Source: Grace Lau

Images from Grace Lau's research archive depicting Chinese 'exotic' types. Lau bought these images as postcards at fairs. The dates and photographers are generally not specified on these postcards – they were printed to promote the work of foreign missionaries abroad.

## Establishing a research framework for practice

As the ideas and research for your project evolve, you will reach a point where you realize that you have created a model way of working for future projects – this is a research framework. Using a research framework that is tried and tested will enable you to progress future projects and help you describe the research methods you intend to use when you write a proposal. You will have a research plan to follow.

## A research framework in action

Sally Verrall is an artist who creates contemporary art and installations. Her work uses mathematics to make images that sit between the virtual and the real world. Verrall uses a range of drawing and paper folding techniques along with maquettes to enable two-dimensional forms to appear to be moving within a single image.

Taking on a disused unit in a soon-to-be-demolished shopping centre, she worked in the space for two weeks with the aim of making a single illusionistic image of a two-dimensional space, projected into three-dimensional space. In order to achieve this, Verrall had to methodically plan and research beforehand. She drew simple drawings to work out what she needed to do in order to create an illusionistic photograph.

Her research plan included materials to source, such as the paper and the wallpaper paste used as glue. Verrall printed out a thousand pieces of each shape of paper in three colours. She then worked inside the shop to piece together the shapes.

Polaroid pictures were taken of the finished work, and all the materials destroyed. All of the research, pre-planning and production culminated in the Polaroid images. Verrall achieved her objectives by devising a set of four clearly defined steps, a methodology that she could then follow. It is important to Verrall not to reveal her final working process, in order to maintain the intrigue and curiosity in her work.

As the ideas and research for your project evolve, you will reach a point where you realize that you have created a model way of working for future projects – this is a research framework.

2.17

**Title: Architectureweek (Polaroids and Masking Tape)**

Artist: Sally Verrall

These are the final polaroids from Sally Verrall's project, documenting the final installation of her two-week project.

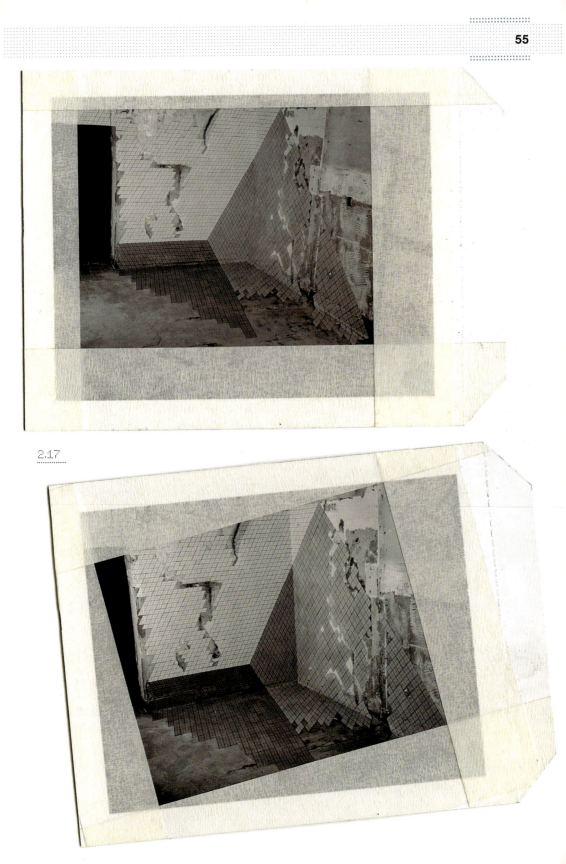

2.17

2.18

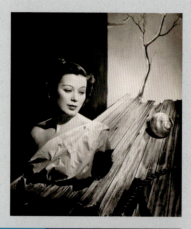

2.18

**Title: Mary Ellis**

Source: Angus McBean/National Portrait Gallery/Harvard University

The portrait Anna with Magnolias from the series 'Flora' was based on Angus McBean's extraordinary photograph of Mary Ellis. McBean was a studio portrait photographer working in the 1930s; he was an important artist working within the Surrealist movement.

2.19

**Title: Anna with Magnolias, *from* 'Flora'**

Artist: Neeta Madahar

After a lengthy research process, only when all the materials had been collected did the process of set building and photography begin. Neeta worked with a lighting technician, Vicki Churchill, as well as a styling assistant, a hair and make-up artist and a photography assistant. All of her portraits for the series were shot in a large photography studio at Southampton Solent University, UK.

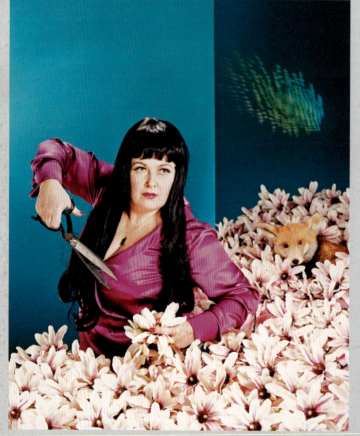

2.19

# Case study 2
# Flora

**Neeta Madahar is an artist who uses photography, amongst other media, to make her work. Her portrait project 'Flora' was exhibited at the National Media Museum in 2009–2010 and published as a book, by Nazraeli Press in 2010.**

In the series 'Flora', Neeta was keen to create a set of fantasy portraits working with several female friends, many of them fellow artists and photographers. Her intention was to use photography to valorize them through an exploration of glamour and desire. She wanted each portrait to be collaborative, so her subjects actively took part in the process and decision-making. For some time, Neeta had been looking into the archive of the photographer Madame Yevonde—particularly the 'Goddesses' series made in 1935. In this series, Yevonde created dynamic colour portraits of society women in costume for a themed ball in a way that turned on its head the conventions of women's glamour portraiture.

As she worked on the research for 'Flora', Neeta expanded her original project outline to look at further society portraiture from the 1930s to the 1950s, including the work of photographers Angus McBean, George Hurrell and Horst P. Horst. Using the imagery she was investigating, and by collaborating with her sitters, she built a picture of how both she and her subject wanted to be represented. Each sitter was also asked to contribute a prop or item of jewellery to their portrait so that the collaborative process had a tangible element.

The images in 'Flora' explore fantasy and desire and display a high level of stylization. All the models, friends of the artist, were over 30 and this exploration with mature women was deliberately designed to challenge the dominant glamour representations of women, which focus on young, photogenic individuals whose images have been digitally enhanced.

2.20

2.20

**Title: Found photograph – Wokingham, UK**

Source: Anna Fox

This photograph was bought at a car boot sale for a couple of pounds. It is a group portrait of what looks like a small private school all dressed up in costume, either ready to perform or perhaps at the end of the play. The head teacher is probably the distinguished looking woman near the centre. The two women on either side of her and the one directly behind her look as if they may be teachers, too. All the boys seem to be dressed up as sailors but the girls do not look like seafaring women. Stories emerge from pictures just by trying to describe how people look or what is happening in them.

# Activity 2
# An illustrated story

For this activity you need to visit a few second-hand shops, auctions or car boot sales. Try to buy a variety of found photographs or postcards; if you are lucky you might find a group of photographs that are from one album, or appear to be linked.

Lay the photographs out on a table and think about where they could be from, who they might represent and why. Start by giving the photographs titles, as if they all belong to the same album or archive – imagine you are recording a history. Make notes about the stories you come up with for each image. Hopefully, you will have some images of people—try to imagine who they are and what their lives might have been like. Again, write all of this down.

Once you have a reasonable amount of fictionalized writing, you can start to create an illustrated story combining the images with your text. You could do this in a notebook, or digitally, on your computer.

Once you have created your story, re-examine the photographs and try to find out as much as you can about where and when they were really taken. You will need to look carefully at the architecture and costume; perhaps there is text on the back of the image that tells you the date and place the photograph was taken.

You could try to find a local museum or historian who could help trace the period or place. Through your research you will start to build a more accurate story about the people in the pictures.

You can also look at how museums use information alongside photographs and how this might narrate history. Compare this with writers such as W.G. Sebald or Roma Tearne, who have used found photographs as part of fictional narratives.

You could also approach this exercise in another way, by sourcing a selection of images from an historical archive, without considering their background or context. Once you have gathered these images, follow the process outlined above, looking at the images and developing your own narrative interpretations. Once you have done this, you can then begin researching the historical details and facts around the images and comparing these results to your own conclusions.

3.1

3.1

**Title: Andrew Bruce at work in India**

Artist: Andrew Bruce

Andrew Bruce is shown here working with his 10 x 8 inch camera in 2010, looking at the landscape before looking through the camera. Taking landscape photographs in India pushed Bruce to work in a very different style and consider his working methods differently.

# 3 Practice as research

**Practising photography – taking photographs – is a primary part of the research process. It is easy to just shoot photographs and not record what you do, yet if you stop for a moment and consider the significance of how you are photographing – when, where, why, with which tools and what assistance – it all starts to become part of an interesting research story.**

Photographs are made through a process of exploring practical solutions. Photographers try out different cameras, lighting types, times of day for shooting and examine how these factors affect the way the image is recorded on film. In the darkroom or the digital production suite further experiments are conducted with colour, exposure, tone, joining images, changing contrast or adding special filtrations or processes that have a marked effect on the appearance of an image. Practice-based research runs through the whole process of making photographs.

Many photographers document what they do both for their own reference and for posterity. Seeing yourself working either in still photographs or on video can really make you think differently about what you are doing. Analysing results through looking back at different experiments helps you understand how you have arrived at the solution; critically reflecting on how you work contributes to the development of practice.

3.2

Ideas can come from anywhere and inspiration for new projects can strike at any time.

When photographer Jo Longhurst was looking to buy a pet whippet she visited dog rescue centres and top breeders. She realized, through this experience, that the mysterious world of top breeders and show dogs would be fascinating to photograph, and she has spent many years producing work in this field.

Your reasons for making a body of work will ultimately depend on what you want to achieve as a photographer and where your curiosity takes you.

**Decide on a subject matter**

Think about how you are going to explore your chosen subject matter. Many photographers will start with initial test images very early on in the project development. This provides a realistic visual image to work from, one that isn't coming from a preconceived assumption. Making images early on will get you in the rhythm of shooting and seeing your subject matter in a two-dimensional form. Test images can be shot on your mobile phone or a low-resolution camera. At this stage, do not get distracted by feeling that the test images need to be of a high production value.

### Shoot in the early stages

By shooting in the early stages of your project development, while you are still reading various texts and looking at other artists' work, you will begin to visually track your progress. As this process develops, it is possible to see how this type of practical research is informing the way you are recording your subject and constructing your image.

3.2

**Title: Breed**

Photographer: Jo Longhurst

Jo Longhurst has worked with whippets for nearly ten years. Her work explores the intimate relationship between human and dog, and questions what it is to be human today.

Making images early on will get you in the rhythm of shooting and seeing your subject matter in a two-dimensional form.

## Guide the idea through

By guiding an idea through practical research processes, the photographer keeps pushing the possibilities and the boundaries of their original idea. After each shoot, a photographer will review their images and re-evaluate their approach to practice. Using fresh images as research, the photographer considers and reflects on how to improve what has been shot. As a practising photographer, things to consider include: what might happen if I shoot using a different camera format or different lighting? What would happen if images were taken from an alternative point of view?

## Own images as research

By using your own images as research, you can map the practical process and use this to help decide where to go next with the project. When you write an essay, you don't start and finish with your first bullet points; photography is much the same – you need to shape and reshoot images in a similar way to drafting then finalizing an essay.

## Photographs as research

Recording the process of taking photographs provides you with a lifelong document.

You may need someone to help you document this – you and your peers could work together to record each other working.

From an outside point of view, photography may appear to be a lone profession. However, if you look into the history of how photographers work, you discover that many more people than just the photographer have been involved in making a project.

3.3

**Title: Black Lake**

Artist: Afshin Dehkordi

Afshin Dehkordi was born in Iran but moved to the UK as a young child, before the revolution. His work explores his cultural heritage and seeks to uncover how historical events and political unrests mould and affect the landscape. Dehkordi created large-scale images such as this one over a series of annual visits to Iran. During this time, his point of view became increasingly informed by historical and cultural research around the turbulent history of the country.

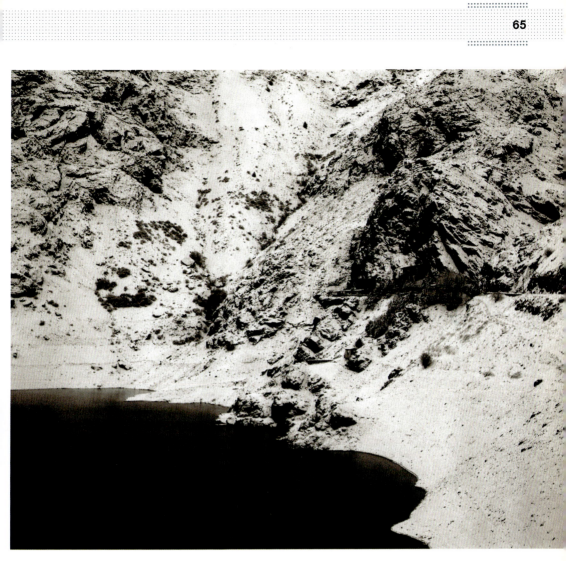

3.3

By using your own images as research you can map the practical process and use this to help decide where to go next with the project.

The studio is an important environment for the making of photographic work. Studio photographers create their photographs by adding and taking away light; they model their subjects with different types of light until they get the result they are looking for. Testing through shooting is a major part of studio practice and the studio photographer will be totally familiar with all the different types of lighting available. Photography is 'light recorded', so being able to see light and understand how it will record is key to all photographic practices.

A studio can be any size, but the size will generally reflect the work that needs to be done. Table-top photography can be created in incredibly small spaces, such as on an ordinary flat table or an infinity table that creates an image which appears to float in space. You could even create a miniature studio with cardboard or wood. Some photographers decide to recreate the idea of a studio on location – by doing this, they make maximum use of available daylight.

A conventional indoor studio only gets daylight through its windows. Some studios have no windows and are entirely artificially lit. A photographer working in a studio with no daylight will have to think about the significance of light from the first moment of shooting.

Being able to see light and understand how it will record is key to all photographic practices.

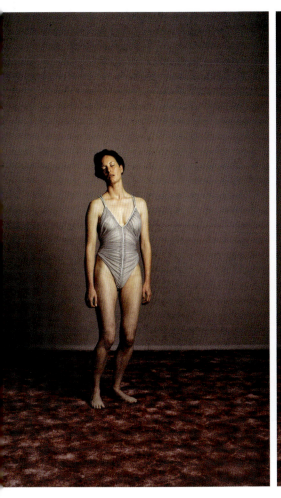

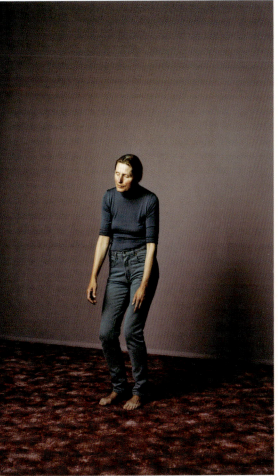

3.4

3.4

**Title: Triptych: In Unheard Contradictions**

Photographer: Anna Linderstam

When first looking at this triptych, it is not clear where it was taken – this ambiguity is created through Linderstam's construction of the studio space. She painted the walls of the studio and installed a large carpet. When the look was perfect, Linderstam had the models hold a single position for an extended period of time to explore the emotional, physical and psychological limits of the human body.

## Studio work as part of the research process

A studio is a site of exploration; it is a space where images are constructed and built up over a period of time, while the photographer constantly reflects and tries out new approaches. There are unlimited possibilities in what can be achieved in the making of studio photography. It is overtly constructed and a studio photographer may well spend days, or even weeks, working on the construction of images. As part of your research process, work in the studio and build in a series of experiments where you test different solutions to how the final image might look.

Lighting is crucial and there are different types of lighting that you could use, such as flashlight, tungsten light or even a domestic light or torch light. Photographers will go through a series of tests before coming to a decision about the final construction of an image or series of images. The photographer also often applies one approach to the whole series so that there is a sense of continuity from start to finish.

3.5

3.5

**Title: Back Side, *from* 'Moronic'**

Photographers: Brendan Baker and Daniel Evans

This image is from a larger body of work, titled 'Moronic'. The series was made collaboratively by two photographers. Using language as a starting point, the work explores the use, control and understanding of specific words in the English language known as oxymorons. To create the visual curiosities of the words the pair worked in both formal and makeshift studio environments. The freedom of the studio space allowed them to combine constructed still life with semi performative techniques.

3.6

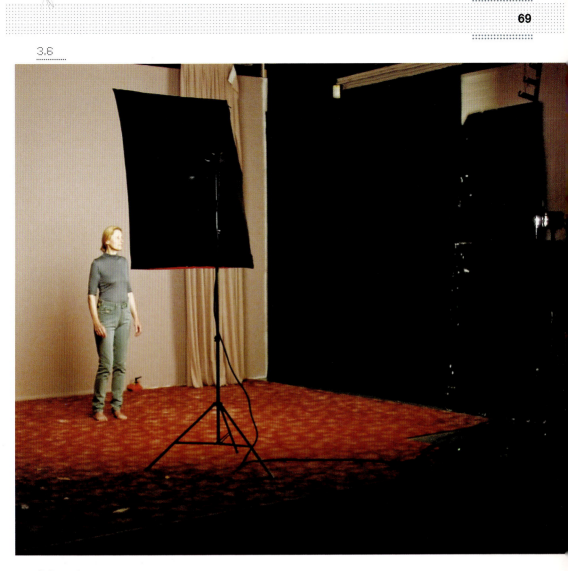

3.6

**Title: The making of Anna Linderstam's 'Triptych: In Unheard Contradictions'**

Photographer: Anna Linderstam

This behind-the-scenes shot shows images for the triptych on the previous pages being made. The images were shot using a large-format 10 x 8 inch camera. Powerful lighting was used, and muted using large softboxes. These create softer light and avoid harsh shadows.

As part of your research process, work in the studio and build in a series of experiments where you test different solutions to how the final image might look.

Street photographers have played a major role in the history of photography. The street is a completely different space from the studio and compositions can emerge in an accidental manner. The photographer has to be ready to capture things that change very quickly. For instance, a cat might walk into the frame or a red car could speed past; this one extra slash of action or colour might be the making of a fantastic image. The street photographer has to be ready for moments to come out of nowhere and react quickly to capture them.

## Subjects on the street

Working on the street, the photographer takes care of where they are and who they photograph. Photographing subjects you encounter on the street can be considered intrusive and raises a number of ethical – and even legal – considerations around privacy and permission. Laws relating to photographing people in public places vary across the world, so you should familiarize yourself with the laws where you are working. You may need to obtain written permission, in a model release form, to use a person's image.

Although some street photographers do not speak to their subject before taking the photograph, you may feel more comfortable working in collaboration with your subjects. This way, both the subject and photographer are involved in the creative process. There are different methods for doing this and exploring these becomes part of your practical research.

3.7

**Title: Untitled, *from* 'Basingstoke'**

Photographer: Anna Fox

This image comes from a larger series about the town of Basingstoke, UK, in the mid-1980s. The photographer worked with a combination of quoted captions and photographs in order to create a strong sense of irony reflecting her concerns about the social environment.

3.8

**Title: Queue for Barneys sale, New York 2010**

Photographer: Anna Fox

Windows (in this case) and mirrors are frequently used by photographers. In street photography, they add another layer to the image, like a filter, and the reflections captured create a more three-dimensional sense of the place. Sometimes, the photographer catches their own reflection in a mirror or window and the image becomes a self-portrait.

## Available backgrounds

3.8

Street photography demands as much practise as any other kind of photography. It is important to learn how to observe the shapes, colours and light surrounding you so that the background in the photographs really works with the structure of the picture. It is worthwhile spending a set amount of time each day, at different times of day, observing changes in light and taking test shots so you start to see how the time of day affects the picture. The weather is also an important consideration: shoot all year round and don't avoid bad weather or low light; different conditions produce interesting photographs.

Visit potential locations in advance, practise what you are going to say when you approach possible subjects and try out different points of view.

3.9

**Title: Untitled, 1953**

Photographer: Vivian Maier

Maier's work has only recently been discovered by an estate agent at a flea market. Maier, who for the most part of her life was a nanny, obsessively photographed in the streets of New York and Chicago. She died shortly before her work was exposed to the world.

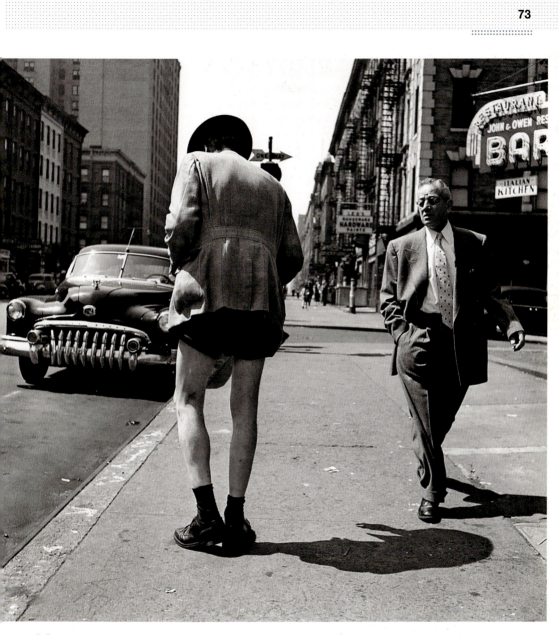

3.9

## Equipment

It is possible to use portable, small-scale flash lighting, or torch light, on the street. This can be alarming to the passer-by, so the photographer with a flashgun is likely to talk to their subjects after the shot has been taken. Some photographers relish the shock effect of the flash and the expressions this produces on the faces of their subjects. Other street photographers do not feel comfortable with this rather bold approach!

Much street photography is shot on 35mm equipment, but trying out other formats can dramatically change the look of the image. Street photographers can employ assistants to help them shoot. This is most useful when heavy, large-format equipment or lighting is being used. An assistant can also be useful to help guard the photographer and their valuable equipment in a busy street.

3.10

**Title: Assisted Self-Portrait of Charmian Edge**

Artist: Charmian Edge/ Anthony Luvera

Anthony Luvera has made a vast body of work concerned with portraying people who live predominantly on the street. He titles the work 'Assisted Self-Portrait', reflecting the way the photograph was taken. It is a collaboration between the artist and his subjects. Luvera aims to give his subjects an equal right to representation —he gets to know them, explains why he is doing the work, they try out different poses and then, when they are both satisfied, the subject presses the button to take the picture with a cable release.

### A change of perspective

The street photographer has to learn to think in a different way from a studio photographer. In the studio you have more control; with time to make plans, to build up lighting and to test it.

In the street there is more pressure to shoot quickly and you may need to shoot a large amount of material before you get the result you are looking for.

Try photographing your subject from different angles, changing the background as you move around. If you only shoot from one perspective you will not be able to see the way an image changes when the point of view is altered.

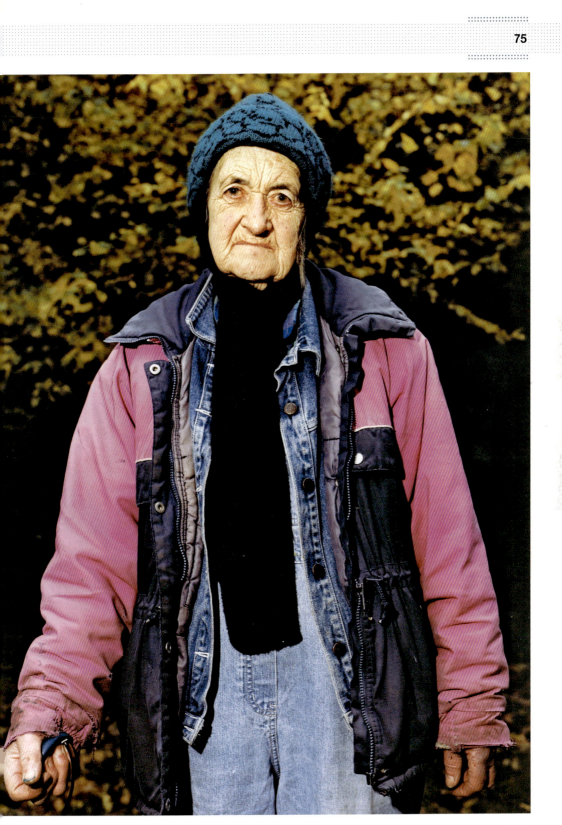

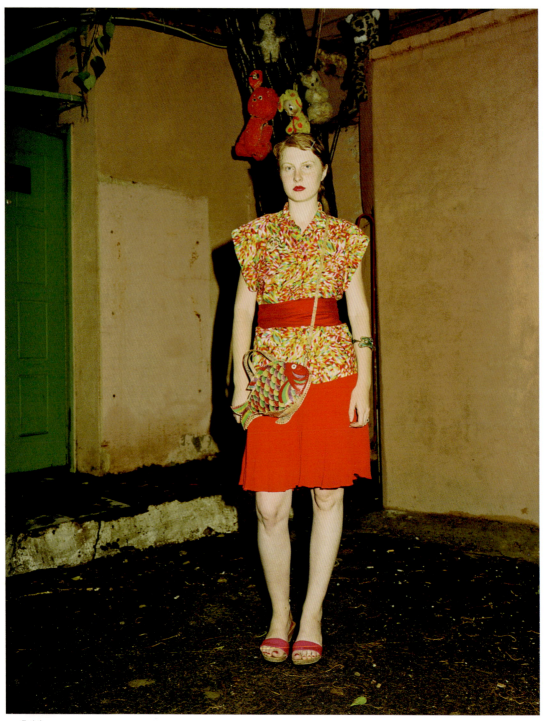

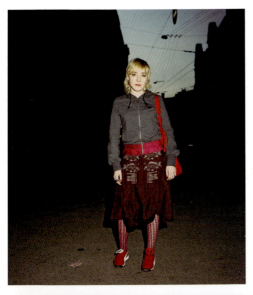

**Title:** *from* **'Moscow Girls'**

**Photographer: Melanie Manchot**

Melanie's series presents the stories of nine young women living in Moscow. The work examines the relationship between the documentary and the fictional, the observed and the constructed. The portraits are exhibited with recorded stories, which can be heard through earphones next to each portrait.

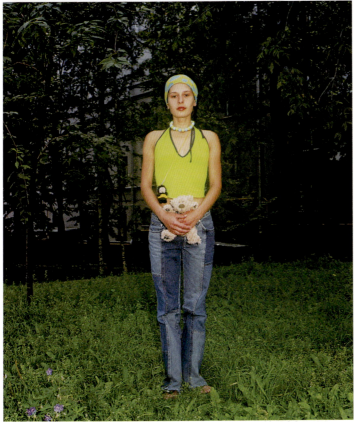

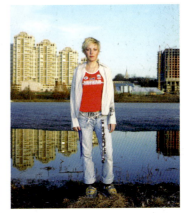

The field in which a photographer works is referred to as a particular genre or style. A genre of photography is essentially a type, such as landscape or documentary. Some photographers work in one genre for the whole of their career, while others will move between different genres. Within each genre there can be numerous different styles of working. An aerial landscape photograph looks completely different from a landscape photograph shot by a photographer working on the ground; these are different styles within the genre of landscape photography.

## The land

Like most photographic genres, landscape photography comes in many guises. A landscape may have a documentary intention, observing social, historical and economic change; be part of a campaign to protect the environment; or be concerned with beauty and the sublime.

The process in landscape photography is likely to be slower than, for example, street photography. Taking test shots and observing how a place looks from different viewpoints at different times forms an interesting part of the practical research for this genre. The landscape photographer may consider where shadows will fall, how the sky looks, what happens to the light in different seasons. For example, in the UK, distinctive golden morning light tends to appear during the winter only.

If you are using colour film, the colour temperature changes at different times of the day and year—this affects the tone of the final work. Images can appear blue or yellow in colour, or have a high/low contrast in black and white; colour temperature and lighting conditions often create these effects. Many landscape photographers will use medium- to large-format cameras to record their image in fine detail and enable them to retain this detail in large-scale prints.

Nature and the rural landscape has been a fascination for both amateur and professional photographers since the invention of the camera. Many questions have been posed about the tendency to romanticize the landscape through photography (and other art forms); these are interesting debates and familiarizing yourself with them will contribute to your research process.

3.12

3.12

**Title: New Street Station, Birmingham, UK**

Photographer: John Davies

Davies, a landscape photographer, is well known for his extensive documentation of the British urban environment. He frequently takes his photographs from high viewpoints; revealing the territory almost as if it is a map. The Birmingham photographs are from Davies's project 'Metropoli', which documented the changing face of the post-industrial cityscape in the UK.

## Documentary and reportage photography

Documentary photography is popularly understood as a story told by a photographer about an event, person or place. It has sometimes been misrepresented as a genre that simply records events and represents the real world. In the last 30 years the use of the term and understanding of the genre has expanded greatly. Documentary photography is now found in many different places including in photographers' monographs, on gallery walls and in magazines. Today's documentary photography can be complex and multi-layered and often demands time to digest its meanings.

Reportage photography, or photojournalism, generally reports on significant, newsworthy events, people and places. Reportage stories are regularly found in magazines, newspapers, books, on the Web and sometimes on gallery walls – notably at the annual *World Press Exhibition*. Photojournalists aim to communicate the significance of their stories as clearly and powerfully as possible. Their photographs have often provided disturbing evidence of world events, and information about lives outside of our own. It is important to remember that both reportage and documentary photographs are mediated by the ideas of their producers and also by the agencies that represent the photographers, or the curators who direct their exhibitions. All of these people influence the selection of images for a series and the context that they finally appear in.

Documentary photographers and photojournalists may specialize in a particular subject or region, and they may work on a story for many years, being sure to research and investigate as many aspects of it as they can. They need to be well informed in order to negotiate the access they require and to shoot in an informed manner. Arts-based documentary practice has scope to be more complex in terms of its narrative and often deals with subjects in a more subtle manner.

3.13

**Title: *from* 'Workstations'**

Photographer: Anna Fox

The series 'Workstations' was shot over approximately 18 months in the 1980s and documents London office life towards the end of Margaret Thatcher's era. Fox used a combination of colour photographs and collected quotes to tell a story that looked critically at working life in the period. The project was commissioned by the Camerawork Gallery and the Museum of London. Anna Harding, the curator of Camerawork, co-edited the project and the work became both a book and a touring exhibition.

3.13

## Art practice

Art practice in photography is one of the most difficult types of photography to define; it is an incredibly broad category that could potentially include many different ways of working. There are numerous junctions where both the history of art and the history of photography meet or cross over. *The Photograph as Contemporary Art* (2009), written by Charlotte Cotton, gives an overview of photography that, today, is considered to be art.

Some people who work with photography as their prime medium define themselves as artists; this is generally because they want their work to be seen within an art history context, which influences the way it is interpreted. There are also artists who use photography (alongside other media) when it is appropriate for a certain project. For example, the artist Gillian Wearing works with video and photography alongside other media, while Rachel Whiteread, who is best known as a sculptor, has also made photographic work.

There are also artists who employ photographers to execute an idea; an artist might do this if they want a particular look to the work that only a skilled photographer can achieve or because the act of employing the photographer is a vital part of the conceptual process. In this case, the artist is operating like an art director or like the director on a movie set. In some cases artists have deliberately ignored both the technical and craft-based aspects of photography, instead embracing a vernacular approach, using a snapshot style to produce their work; again, this act will be purposeful and connected to the intended meaning of the work.

3.14

**Title: Agnieszka *from* 'One Month'**

Photographer: Maria Kapajeva

Maria Kapajeva made a series of before-and-after photographs during a trip to the National Institute of Design in India in 2009. She travelled with a group of students and photographed them all when they arrived, then again when they were about to leave. The resulting diptychs pose questions about identity and its relationship to time, travel and experience.

3.15

**Title: Beyond the View 5**

Artist: Helen Sear

Helen Sear is an example of an artist who uses photography. She has a fine art background in painting and sculpture, and has also used performance and film in her work. Her series 'Beyond the View' explores her interest in the relationships between culture and nature, and the notion of the body in the landscape, using digital layering and drawing to create striking images.

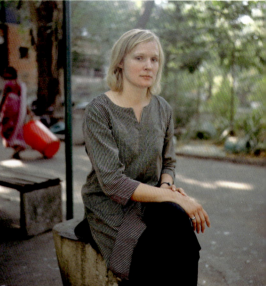

3.14

3.15

## Fashion and advertising

Photographers working in fashion and advertising create some extraordinarily innovative images. These photographs are intended to sell products and lifestyles, and a successful shoot will show these in such a way that they are understood and made desirable. Most fashion and advertising photographs are created through teamwork, and photographers in this field are likely to work alongside an art director, who will direct the shoot, and a number of assistants and stylists. These shoots can attract high budgets and the elaborate work produced often reflects this investment, as different levels and types of production can be explored with larger budgets. Fashion photographers often have to produce a large volume of editorial work for very little pay before winning commercial commissions.

Fashion and advertising photographers may also be recognized as artists in their own right. Artist and photographer Man Ray produced some groundbreaking fashion photographs alongside his artistic practice, and photographers continue to do this today.

Both advertising and fashion photography are clearly constructed, but they can veer from creating images in a documentary style through to images that are overtly fabricated; constructed either in a studio or on location. Constructed photography is created both by commercial photographers, in advertising and fashion, and by artists for their own work; art and commerce frequently influence one another.

3.16

**Title: 'Power Suit' editorial, _Muse Magazine_**

Model: Hanne Gaby

Photographer: Robert Wyatt

Robert Wyatt is a fashion photographer who has worked for numerous high-profile clients, including Prada, Valentino and British Airways. He regularly has his work published in magazines such as Vogue and i-D. Wyatt started working as a gallery-based photographer and continues to work on his own projects alongside his fashion and advertising commissions. More of his work can be seen online at <www.robertwyatt.net>.

← Street photography | **Style, genre, medium and technique** | Post production →

## Technique, medium and style

Photography can be studied from many different perspectives: artistic, scientific, historical, theoretical, craft-based or philosophical. By looking at various genres of photography, we are concentrating primarily on the field of visual arts, crafts and media. As well as thinking about and testing out a particular genre to work within, it is interesting to explore the various technical aspects of photography.

The camera itself provides multiple possibilities for the ways in which a photographer can take photographs. Aperture, shutter speed and camera type all affect the nature of the photograph produced. It is valuable to explore all aspects of the camera as part of the practical research process, as well as testing how your photographs work in different formats. The difference between shooting on 35mm and 10 x 8 inch film is vast, with the results being most acutely noticed when large-scale prints are produced for exhibition. The choice of aperture and shutter speed affect the look of an image; the depth of focus, the detail and the exposure of an image can all radically change the impression created.

Photographers experiment with different types of film to find out which best suits the work they are making. Each make of film has a distinct appearance when printed—one colour film may produce much warmer results than another. ISO ratings (film speed) also affect the resulting image—slower film has a finer grain, and will produce clearer detail in the print, whereas fast films often produce grainy results. You can also experiment with over- and under-exposing film, as well as over- and under-developing it when processing.

When testing films and cameras, you should keep detailed notes on what you have done, so that when the photographs are printed you will have a record of how they can be recreated. Bring the prints and the technical shooting notes together in your research documentation in order to archive the findings of your exploration.

When testing films and cameras, you should keep detailed notes on what you have done, so that when the photographs are printed you will have a record of how they can be recreated.

3.17

3.17

**Title: Double exposure**

Photographer: Anna Fox

This film was accidentally put through the camera twice and so two different sets of images were taken, one on top of the other. Double exposure can be used in a planned way, but it is always difficult to predict what will happen—and that is part of the excitement.

3.18

**Title: Cat (Cyan 0, Yellow 60, Magenta 81),** *from* **'The Chase'**

Artist: Dean Hollowood

Dean Hollowood's series 'The Chase' was produced through experimentation with colour, tone and the layering of photographic paper in the darkroom. The positioning and exposure record of each test strip cannot be reproduced, so each image provides a new expression of the subtle variations in conditions that gave rise to it. Using an element of chance to create this work contrasts with the controlled predictability of digital methods.

3.19

**Title: Office Buildings**

Artist: Louis Fox

An art student transforms his photograph of a city building into a monoprint by placing a piece of white paper onto an inked board, then placing a digital print of the image facing upwards on top of this. He draws onto the photograph (following the lines of the building) and the ink is transferred onto the blank sheet of paper below. Later experiments included creating montages using the monoprint, in both positive and negative, combined with drawn lines.

3.19

Any work done to alter a photograph after it has been taken falls under the term post production. Post production can be conducted in an analogue darkroom or in a digital production suite, with adjustments being made to alter the look of the image and ultimately affect the way it is seen and understood.

In analogue photography this process starts with the development of the film; photographers can alter the way a film is developed to change the look of the resulting photographs. When working digitally this can be done using a post-production program. During the printing stages of both analogue and digital photography, numerous changes and adjustments can be made.

## The darkroom

Taking photographs at the start of a project is like executing the preliminary sketches for a body of work. Post-production work in the darkroom represents the later stages of this process where you finalize the look of a print or a whole body of work. There are endless possibilities in the analogue darkroom; testing different output techniques can transform an image.

Commercial analogue darkrooms are closing at a dramatic rate. In 2006, there were more than 200 darkrooms run by printers in London, but by 2011 there were only six left. It is still possible to set up your own black-and-white darkroom at a small cost and with little space.

Getting lost in the quiet and stillness of a darkroom is an exciting and enriching experience. To get an idea of the numerous printing techniques possible in the darkroom, it is well worth reading one of the excellent photography manuals, such as *Langford's Basic Photography* (2010; 9th edition). Michael Langford's *The Darkroom Handbook* (1988), gives you more detail on what to do in the darkroom.

There are endless possibilities in the analogue darkroom; testing different output techniques can transform an image.

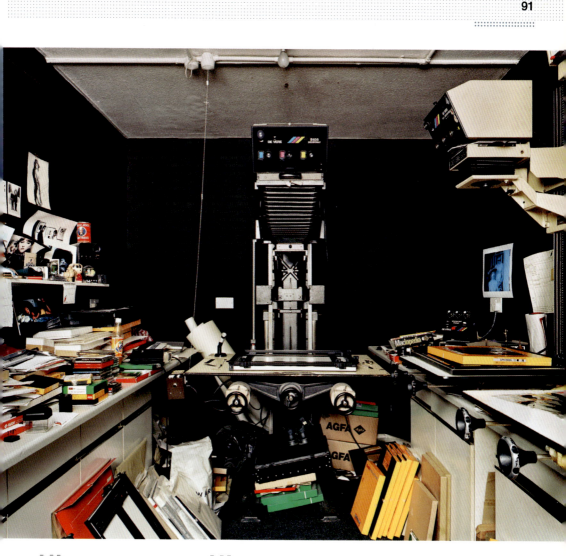

3.20

3.20

**Title: Brian Dowling, BDI, 2006, *from* 'Last One Out, Please Turn On The Light'**

Photographer: Richard Nicholson

In Richard Nicholson's series of colour photographs of London darkrooms, he observes and records the slow disappearance of analogue production spaces. By photographing the darkrooms before they become redundant, he has created a valuable archive.

The images' vivid aesthetic is created by shooting with large-format film in pitch black, lit by a series of continuous flashes, which were made by moving carefully around the space with a hand-held flash gun.

## Toning images

You may wish to tone or solarize an image as part of your post-production work. How will this affect the reading of the image? Test it out and ask people. Experimenting with toning can lead to a new and exciting end result. Toning can be achieved both in the darkroom or digitally.

Toning affects images in different ways. Sepia toning browns the image, making it appear aged, whereas selenium toning brings out the metallic silvers, therefore increasing the depth of tone in the blacks and whites of the photograph. Selenium toning is now prohibited in most colleges; if you do have access to it, instructions should be followed with great care.

3.21

**Title: An Angel Appears**

**Artist: Richard Sawdon Smith**

Many of Richard Sawdon Smith's photographs are created by experimenting in the darkroom with different printing processes and toning techniques. Influenced by the photographer Joel-Peter Witkin, he is not afraid to interfere with negatives—cutting them up, scratching the negatives to create black marks, building up texture or aging the look of the images. The choice of models, backdrops and hanging fabrics, the use of the toned black-and-white images with the various effects, are all part of a process to create contemporary images that remain timeless.

3.21

3.22

**Title: Little Black Dress**

Artist: Joy Gregory

This image is from Joy Gregory's series 'Girl Thing', for which she produced cyanotypes — an old photographic printing process that results in a cyan coloured print. Cyanotypes were used by engineers from the early 20th century to produce large-scale copies of their work, called blueprints. The artist uses the process to explore gender construction through the association between an object and a 'feminine' description.

## Digital post production

Digital post production is a key part of the contemporary photographic environment. Many photographers who shoot on film choose to scan and print their images digitally, allowing them to benefit from all the possibilities of digital post production.

A whole new wave of photographic approaches have come out of the innovative knowledge gained through digital experimentation. Images can now be created and manipulated through various means: by digitally joining negatives, adding and taking away whole elements, replacing one thing with another, montaging different images together and simply experimenting with a whole range of digital effects. The digital post-production suite is a place where the most elaborate illusions can be constructed. There has never been a time where the blending of fact and fiction has been so potent and seamless.

Your early explorations in the digital suite will illustrate the huge number of possible outcomes; it is easy to get carried away and to 'over do' digital effects. Try everything out in the various digital programs and then consider what meaning the altered image might have. If the digital effect or combination of effects dominates the image, it can take something away from the intention of the work. Tests can be collated in your research archive or workbook, and an analysis of these will help you decide what you should do and which program to use.

3.23

**Title: Flight to Freedom,**
*from* **'India Song'**

Photographer: Karen Knorr

Knorr created this image by digitally joining two photographs. We are easily convinced by the illusion that a white crane is walking through the palace. Knorr's work is concerned with the position of Indian women in society, and with feminine subjectivity. The way birds and animals appear in this series, combined with the captions and titles, creates a sense of containment, a domestication and desire to escape.

3.24

```
stewed

boiled

potted

corned

pickled

preserved

canned

fried to the hat
```

The exploration, experimentation, reading and thinking that you do through the course of your research will play a significant role in informing the way you resolve a body of work. Research does not usually lead straight into the making of the work; more often it sinks in slowly, over a period of time, subtly affecting and changing the way you work and what you decide to concentrate on.

Sometimes your research may affect your practice more directly; you may discover something that changes your opinion, idea or approach.

Archiving everything in a way that you can easily refer back to will help you apply the research you have done to your practice. Your project may start with basic research into a subject, theme or technique, but equally it may start through taking photographs and realizing, on reflection, the potential for further work. You might be inspired by being somewhere or hearing something, or through reading, looking or watching. Essentially, recording how a project or body of work develops allows the photographer to see how different types of research have informed and affected the work, and shows that all aspects of a project are part of a research process.

## Time

Time is an important part of the research process; we all look at things differently as time passes and the direction of a project can change radically when it is made over several years. Many projects have to be finished quite quickly. An editorial portrait, for example, may be requested by a picture editor one day, shot the next and published the next — it is a fast-paced world. However, this does not affect the fact that your approach to photographing will change over time and is influenced by all of the different types of research you do.

3.24

**Title: The Bowery in two inadequate descriptive systems**

Artist: Martha Rosler

Martha Rosler's work is informed by her keen commitment to questioning politics (both in society and in representation) and to creating awareness of social issues. Through her strategy of combining text (in this case: stewed, boiled, potted, corned, pickled, preserved, canned, fried to the hat) and image, she highlights the problems of documentary practice, both visual and text-based. The title plays a key role in directing the viewer to the meaning of the work. The Bowery is the oldest thoroughfare on Manhattan Island, New York. In the 1970s it was very run down, a typical area for documentary photographers to record. Rosler questions both photography and text as methods of recording such a place.

Editing involves selecting final images from a larger body of initial work. It is a slow process that demands careful thought and often benefits from the opinions of others, both professionals and non-professionals alike. A professional editor or curator can provide an expert view on how to select work for a publication or a particular space. You can also experiment with editing in small groups by handing your work to someone else and asking them to select a meaningful series from the photographs. Once the trial edit is done, the rest of the group can explore through discussion how they understand the story or the meaning of the work. This process will enable you to think more clearly about how others react to and understand your photographs; you will gain a distance from the work that is invaluable in making editing decisions.

**Reflection**

In order to successfully edit your work, you will need to reflect on it. Reflection is the process of looking back on what you have done; analysing, reconsidering and questioning what has happened and why. Strategies for reflecting on your own work could include asking yourself, is it working? Which images are really saying what I want them to say? If there is only one image that interests you, concentrate on this image and try to determine exactly what makes it successful.

Think of alternatives. Look for other points of view. Look for hidden assumptions and challenge them. Look at the work from the opposite point of view. How does it look now?

Through reflection, you are able to create new knowledge that is born of old knowledge. This is achieved by giving yourself the space and time to look back on your progress.

If there is only one image that interests you, concentrate on this image and try to determine exactly what makes it successful.

3.25

**Title: 'Match Day' contact sheet**

Photographer: Chris Linaker

A documentary photographer will take numerous photographs and edit as they go along. This contact sheet shows how Chris Linaker uses coloured dots to indicate the images he is interested in for a first edit; he will then make working prints of the shortlisted images and use these to help decide how to refine his approach in the next shoot. The working prints become part of his archive and will be used in the second stage of editing, during which they are collected and laid out before the next draft edit is made.

Evaluation involves analysing what you have done, judging the evidence you have found and then, most importantly, responding to the information and making appropriate changes. The process of evaluation can take place at regular intervals—you should do it after each shoot and at the end of the project.

It is very helpful to evaluate the progress of your work against your proposal or your initial aims and objectives. By formally assessing and judging the value of a particular piece of work, you can begin to see what improvements can be made. We evaluate things all the time—it's part of everyday life. It can be difficult to evaluate your own work, however, so it is useful to ask yourself a series of questions that you can answer in written form.

## Questions and answers

The following are examples of questions asked and answered during the process of evaluation:

- How well is the project going?
- What improvements can I make?
- How has it changed from the original project proposal?
- What are the strengths of the project so far?
- What aspect am I enjoying?

Appraise the weaknesses and strengths of the project. Keep a record of your answers. It is easy to focus on the areas you are finding difficult or to concentrate on what isn't going well. However, it is always important to evaluate the positive aspects of a project as well as the negative. Drawing attention to what is going well and what you are enjoying is a powerful motivator.

3.26

**Title: Project evaluation form**

Source: Natasha Caruana

Evaluation is a fundamental part of the creative process. The first few times you are evaluating pieces of your work, it is useful to follow the structure of a form such as this. The questions will help you to focus your thoughts clearly and get the most out of the self-evaluation process.

**PHOTOGRAPHY PROJECT SELF-EVALUATION FORM**

Project:                                    Date:

1. **PROJECT TITLE** — How did this develop from your working title and what was involved in the decision-making process?

---

2. **SUBJECT** — Reflect on the subject matter of your project and the background research on this subject.

---

3. **AIMS/OBJECTIVES/CONCEPTS** — How and to what extent have you achieved the aims and objectives of your project? Describe the main concept driving your project.

---

4. **AUDIENCE** — Are you addressing a specific audience with your piece of work? For example, your peers, members of your family, or patients of a hospital department.

---

5. **CONTEXT** — What is the context of your project? Is it going to be viewed in a gallery space, a magazine, an artist's book, on the Internet, on a book cover?

---

6. **FORM/MEDIUM/PRESENTATION** — What is the final form and method of presentation for your work and why did you come to choose these?

---

7. **RESEARCH METHODS** — What research methods did you use to research this work and how did this research inform your project?

---

8. **REFERENCES** — How useful were the references you explored — the artists, writers, or film-makers? How do you think your project would function in similar contemporary fields of production?

By thinking about practice as a research process, you are allowing yourself the space and time to be able to make mistakes and to make any improvements you feel are necessary. You should never be afraid of making mistakes or pushing yourself into unknown territory. This is often when image making is at its most exciting. Making improvements is a positive process – re-shooting is a healthy and worthwhile exercise. Or you may choose to improve single images from a series in post production.

You are also allowing yourself time to reflect and act on your judgement, or the judgement of others. It is important to learn not to take the judgement of others on your work as absolute – your own intuition is invaluable. The perspective achieved through taking time to evaluate and judge one of your projects can inform your approach to the next body of work.

It is difficult for both emerging and experienced photographers to be fully satisfied with a body of work. However, there comes a time when your work needs to revealed to an audience.

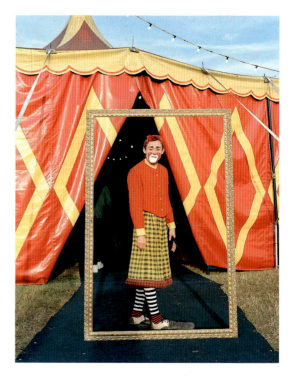

3.27

3.27

**Title: The Clown, 2004**

Photographer: Natasha Caruana

For the last seven years, Natasha Caruana has been making work around the clown community from a personal perspective —she is the daughter of a clown. She used props to try to capture the persona of a clown. She evaluated her first images and concluded that they were overly predictable. Through her research, she developed different ideas about how to represent the clowns in a way that challenged our perceived views.

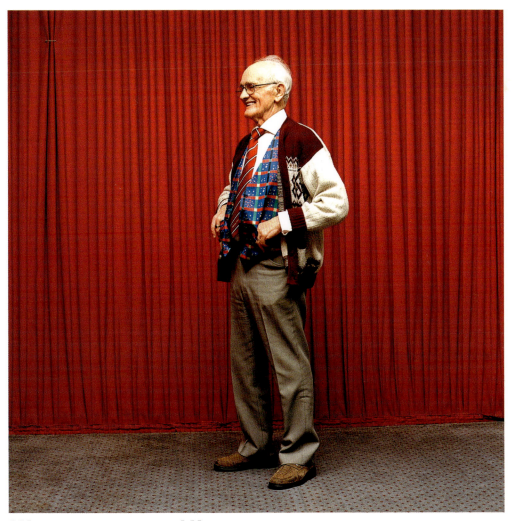

3.28

3.28

**Title: Dizzy the Clown, 2009**

Photographer: Natasha Caruana

Caruana continued shooting while researching and getting to know the older clowns beyond their performed personas. She documented unguarded moments at committee meetings, in dressing rooms and in living rooms.

This latest series of portraits captures the clown out of costume. Through the detail in the image, the audience is drawn to imagine how this man performs as a clown. This is a development from the more literal perspective she used in the previous portraits, made in 2004.

3.29

3.29

**Title: *from* 'Where am I Going?'**

Photographer: Helen Goodin

This series was taken at night using black-and-white film and a portable flash gun, while Goodin wandered around the small town where she lives. The edges of the town are predominantly unlit so she did not see the resulting image until she had processed the film and made prints.

3.30

**Title: *from* 'Source'**

Photographer: Helen Goodin

'Source' references the fact that all photographs are made from a light source. The light source here is simply the light from the enlarger: there is no negative and no camera – this is cameraless photography.

The resulting images appear like glowing orbs or planets, and Goodin has explored the presentation of this work for exhibition in grids and at different scales. Through her practical and theoretical approach Goodin asks: 'If photography is about seeing, and looking at things, then what do we see?'

# Case study 3
# Helen Goodin

Helen Goodin works with the very essence of photography. Through her research process she has evolved a way of thinking about photography in its most primitive form: simply as light. During an intensive period of practical and theoretical research, Helen went through a series of different approaches to making images. Her theoretical research included analysing texts by writers, artists, scientists, theorists and philosophers from David Campany to Wittgenstein and Paul Graham. She read key texts and commented on them in her research blog. She also attended conferences and talks and, when possible, talked to the artists and writers in person about their ideas.

Her practice-based research included a series of disparate approaches, all the time searching for a way to visually convey her thinking. Goodin tried numerous ways of making images. At one point, she walked around her local town in the dead of night, in areas where the street lighting was low or non-existent, with black-and-white film in her medium-format camera and a portable flash gun. She simply pointed the camera out into the darkness, lighting the scene with an explosion of light from the flash – using artificial light to illuminate a space in which the human eye was virtually blind.

In her most recent work, 'Source', Goodin has started exploring the making of images by simply using the light in the enlarger of a colour analogue darkroom. Through a process of practical experimentation in the darkroom, she has explored different ways of transmitting light from the enlarger onto photographic paper. Changing the filtration of magenta, cyan and yellow light as it fell from the enlarger onto the photographic paper, she witnessed how the images mutated.

The science of photography has been an important line of enquiry in this work. It is from this that Goodin has really found what she is interested in and where her practice stands.

3.31

**Title: Still Life with Fruit, 1860**

Source / Photographer:
Scala/Roger Fenton

Fenton's original Still Life With Fruit,
shot in his studio in 1860.

3.32

**Title: Remake of Fenton original,
2010**

Source: Photography students,
UCA, Farnham, UK

This image is a remake of the
Fenton image. Shot on a digital
camera, it replicates the lighting
Fenton used. However, where
Fenton used natural light from large
skylights on the roof of his studio,
this new scene is lit using a large
soft box placed directly above the
set. The photographers worked
as a group to replicate the form of
the fruit in Fenton's image, using
autumn leaves, backpacks and other
available materials.

# Activity 3
# Pioneers of photography

For this activity you need to gather a series of examples of other photographers' work. During your research process you will have looked at both contemporary and historical work. By looking back at one of the pioneers of photography as a reference, you can relate your work to the history of visual practices.

The pioneers of photography can be found by searching your local library, an archive or by looking online. Try to find a variety of styles and techniques within the work, look for images that are linked to your interests through content, lighting, style or context.

Now select one image to work with; study this image more closely. Take notes describing how the photographer has used lighting. Reflect on what you think they are trying to say. Evaluate the strengths and weaknesses of the image. What makes it work? Write down all of your thoughts.

Look back at your notes and consider how you could begin to visually interpret the photographer's image and use this information in the making of your image.

Using the information you have gathered, remake the image that you selected. It is good practice to recreate the image precisely before reinterpreting it. It is also good practice to work in the studio with professional equipment in order to imitate precisely the lighting used. By remaking the image, you will notice details that you might otherwise have missed.

Think about how you can update the image. What modern-day props could you use? Could you apply the same technique, but use different content? Or use the same content, but a different technique? Now you are not trying to reproduce the image – instead, you are trying to reinterpret it.

Remaking a great work of photography gives you an appreciation of how far photography has evolved. It will give you an awareness of the energy and effort used to produce images in the early days of photography. It may seem a speedier process today, but we still need to invest time, energy and thought to make interesting images.

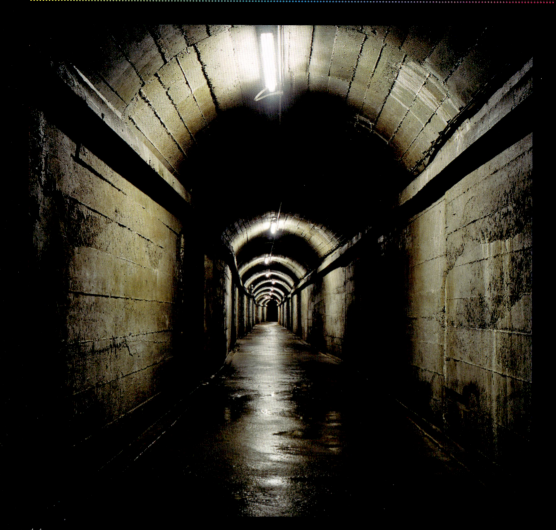

4.1

4.1

**Title: Abteilung Nr/W, 2004–2009**

Artist: Fiona Crisp

Artist Fiona Crisp's image of an underground World War II hospital on the Channel Islands, which is now a tourist destination, questions the complex relationship between leisure and heritage. The image was featured in Crisp's monograph *Hyper Passive*, and Crisp describes the making of the book as a defining moment in the organization and dissemination of her stored research. She uses different methods and locations to compile her work, with large-scale prints in storage, and other materials such as objects, data, negatives and working prints, stored at home.

# 4 Compiling your research

**Research materials need to be compiled in such a way that they are user friendly, so that you, as well as other interested researchers, can make the best use of them.**

Each photographer will have a different method or system for compiling their research. There is no right or wrong way – you need to find the approach that works best for you. The way you choose to store or catalogue your research does not have to look pretty, but it does need to be accessible enough to inform your work; it will require some additional effort to organize and structure your research materials. If your research is in a manageable order it will be easier to create a clear and organized project.

It is important to remember that, whatever method you select to compile your research, there must be space for it to evolve, grow and develop along with the project itself. Allowing the research to have significance will add authority to your practice as a whole.

This chapter looks at some of the methods that are available to you for compiling your research materials, and also for storing them.

A visual journal, workbook or sketchbook is a physical manifestation of your thought processes. It is a space to play, a sounding board for developing different ideas and a place to track developments. You need to decide if your visual journal is a travel companion – if it is, it will need to be a suitable size. It may be that you use a small journal to record everyday thoughts that can then be transferred to a larger, master journal. The process of transferring this information may also invite further reflection.

Thought processes can be tracked, and all sorts of materials – photographs, photocopied and found images, written fragments, quotes and interviews, letters, lists, technical details, real or fictitious notations – are potentially relevant and can be included in your journal.

## Digital workbooks

Keeping a digital workbook may be more appropriate if you have collated a lot of digital materials and images. You can add your thoughts in the form of typed notes, rather than transferring them to a handwritten sketchbook or journal. The Internet is a wonderfully liberating research resource, though you do have to analyse the material you find there to determine its credibility and relevance. Digital workbooks allow you to seamlessly collate your Internet research.

The results of using a digital workbook are quite different from a physical workbook and you should consider which way is most appropriate for your work. Although it seems environmentally unsound, you may find it helpful to print out a digital notebook or workbook in order to see the pages side by side. Alternatively you may be able to view all the pages on screen as thumbnails. Measuring where you have been and forecasting where you are going can be difficult if you cannot view several pages at the same time.

### Keeping a workbook

Workbooks should be made in a way that suits you; there is no set formula. You may come across a completely new way of recording your research.

A workbook can be private or public; in the first instance it is a place for personal reflection and so it should not be overly self conscious – it is not necessarily for public consumption.

Make your workbook a pleasurable space to explore your thoughts and ideas.

In a digital workbook, links to relevant subject matter and images can easily be added between the text entries. For example, you can copy gallery opening times onto your research page or drag across interesting images. You can collate screen shots and add video clips.

If you have a laptop computer, keep a folder on your desktop and carry it around with you. Create document pages with Adobe InDesign, Photoshop or with Microsoft Word; these are transportable between laptops, studio desktops, and some mobile phones. The information on your digital workbook can easily be shared – it can be emailed and added to your Facebook page. You can also invite online reviews from peers, giving you a response to your work in progress.

4.2

**Title: Sketchbook page from the project 'Hackney eyes'**

Source: Simon Aeppli

Keeping visual journals such as this has been central to Simon Aeppli's practice as a film-maker and photographer for the last ten years. He uses his visual journals as a starting point for his finished work, which interweaves video footage with images from books.

4.2

Creating a blog allows increased functionality above simply digitizing and compiling your research material. The thought of setting up a blog can be daunting, as they are often perceived as being solely text based. On the contrary, blogs are highly flexible and can be whatever you want them to be.

Following an online blog template gives you full control over all of your materials, whether you want them to be visible on the Internet or hidden. A blog can have private sections or, by choosing a 'closed' blog, which can only be accessed via a password, it can become a completely private working space. A blog can also be an open working space with access for all. Consider whether your research will be enhanced by allowing people to comment on your entries or by allowing them to share your entries with the rest of the Web.

## The advantages of blogging

Using a blog makes your research fully transportable between working environments and even countries: as long as there is Internet access, you can have access to all of your research material.

By creating different online entries, you can model the structure of your blog on the pages of a physical workbook, creating an online journal.

One of the key benefits of using a blog is that you are able to tag each entry with keywords. By using this tag system, you can organize all of your information and, over time, create your own catalogue. The blog archives become more valuable over time. Using a search function, connections are made between entries that might not otherwise have been obvious.

## Blogs for organizing and compiling research

Blogs can also be used in a more public realm. Unlike the diaristic use of blogs previously discussed, photographers can also use their blogs to help compile research that is then structured by subject matter. The subject-specific sections of the blog encourage you to reflect on the relevant compiled material whilst sharing it with your online audience.

If you are choosing to compile your research using a blog, it is good working practice to make regular backups of your blog entries to protect your work. There are numerous issues to do with hacking and servers crashing that could affect your blog, and cause you to lose work that has not been backed up.

4.3

Title: Images from a
photographer's blog

Source:

Photographer Carole Evans uses her blog to discuss current exhibitions, images, and publications that are of interest to her and relevant to her photographic practice. Blog entries are organized by date, and there are a number of links to other photography blogs.

### Photography blogs

Try to familiarize yourself with as many different photography-related blogs as you can, and compare how they each present and organize their information and images. Some examples of interesting blogs are included below – some of these have links to other blogs that you may also want to investigate.

Amy Stein is a teacher and fine art photographer who is based in New York:

Alec Sloth is an American photographer who set up a blog for his publishing company, Little Brown Mushroom:

Carole Evans is a professional photographer who also works as a curator in London:

Photography magazine *1000 Words* has a blog alongside its website:
<1000wordsphotographymagazine.blogspot.com/>

*HotShoe* is a contemporary photography magazine, which also keeps a blog:

Once you have completed a project, you will have collected a significant amount of physical research material that you may only need to access from time to time. It is therefore important to give some consideration to the storage and organization of this material. Some photographers use a system of boxes or folders during the course of their project. It could even be as simple as a collection of open shoe boxes in the corner of a workroom.

You will need to keep your material well organized so that it is easily accessible for future reference. The items will also need to be stored safely. As a basic rule your items will need to be kept in a dry environment and out of direct sunlight in order to avoid fading or bleaching.

## Forms of storage

Archival boxes are used both by individuals and organizations; they provide an efficient means of storage as well as an appropriate amount of protection. Typically, archival boxes are made out of corrugated plastics or acid-free material. They are normally crushproof and water resistant. Choosing an acid-free material will ensure that delicate contents, such as manuscripts, newspapers and maps, will not degrade too severely over time.

Negatives and prints should be kept cool to keep them in good condition. In the US, archives of negatives and colour prints are frequently frozen. Researchers who want to view the material have to book appointments and the work is taken out of the freezer in advance of their arrival at the archive.

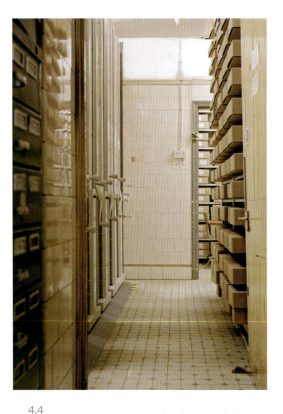

4.4

**Title: Basement Archive, Wiener Library**

Photographer: Ali Mobassar

The Wiener Library Institute of Contemporary History in London holds more than ten thousand historically significant photographs, as well as books, pamphlets and other materials. Very careful consideration has been given to the safe storage and archiving of each of these items. Considering appropriate forms of storage is key to all archiving, whether you are preserving a large, historically significant collection such as this, or organizing your own project research materials.

**Title: A photographer's archive**

Photographer: Natasha Caruana

This archive demonstrates a
range of approaches to securing
and organizing research material.
In a small corner of the studio,
negatives are stored in acid-
free negative boxes; a system
of named folders organizes the
material and green archival boxes
store a valuable collection of
vernacular photography, magazines,
newspapers and old family albums.

4.5

4.7

4.6

4.6

**Title: Putting On: The 3 Proprietors**

Artists: Natasha Caruana, Wiebke Leister, Daphne Plessner

'Putting On: The 3 Proprietors' mimics the poses and postures of highly stylized group portraits of acrobats, clowns and other circus artistes from the turn of the 20th century and beyond. At the same time the title recalls the three rings of the circus in which the directing proprietors curate the respective performances. Research and practice-led experimentation is central to this series.

4.7

**Title: Three young unidentified clowns performing an act with hats**

Source: Victoria and Albert Museum, Hippisley Coxe Archive

The images from this archive tell the story of the performing arts in Britain from the 16th century to the present. It covers all the live performing arts including drama, dance, opera, musical theatre, circus, puppetry, music hall and live art.

# Case study 4
# Putting On

'Putting On' is a subject-specific artists' collective with three members: Natasha Caruana, Wiebke Leister and Daphne Plessner. The collective explores the evolution of the clown figure in its age-old roles as masquerading fool, trickster, joker and jester. The practice of each artist explores different elements of the above – comedy, subversion and the carnivalesque – and this enriches the collective as a whole.

The photographic project 'Putting On: The 3 Proprietors' revisits poses of circus artistes from the turn of the 20th century. To investigate the visual history of these images, the group viewed the Hippisley Coxe collection at the Theatre and Performance Archive of the Victoria and Albert Museum in London. This proved to be a rich source of group portraits in intriguing poses and unique make-up from different periods and theatrical genres.

Researching the history of this type of imagery informed the collective's understanding of the different origins of clown types and helped them to choose the poses and costumes that featured in 'The 3 Proprietors' series. The collective also looked at circus posters with portraits of ringmasters and owners (the proprietors), which led them to examine the role of artists as producers and managers of their own artworks.

Discussion around experimentation and process is central to the collective's work, as is the collation of each member's individual research findings in a joint archive. The process of visiting archives and galleries, swapping images and sharing references on the history of humour and clowning was integral to the creation of the Proprietors series, in which the artists performed different sets of poses for the camera.

This background research also led to writing a manifesto that outlines different kinds of clowns throughout history in relation to the aims of the collective. This manifesto was performed as part of a radio discussion about the role of the female clown and published in a journal.

4.8

**Title: Foodspotting, *from*
'Bloggers'**

Photographer: Gabriela Herman

Gabriela Herman's 2010 series, 'Bloggers', features portraits of people, illuminated by the light from their computer screens, as they update their blogs. The series explores how, from these dark corners, bloggers are changing the ways people interact in the world.

# Activity 4
# Start your own blog

For this activity, you will set up a private blog as a means of compiling your research. You need to have an idea for the project you would like to work on next. Write a rough title and a few notes on your ideas, and make this the starting point for the direction your blog research will take.

Sign up to a blog service online. Blogspot, Wordpress and Tumblr are a few of the most popular blog storage services, and they are all free and user friendly.

Record all of your research on your private blog over a period of one week. Take into account what you see around you. Make an entry every day recording your thoughts and the work you have done; remember to monitor and evaluate your progress in order to be able to reflect back at a later stage. This exercise will make you aware of how much research you can gather in one week.

Think about the structure of your blog – what approach would best suit your working methods? Do you want to record all of the information you gather using the structure of a daily entry? Or do you want to structure your entries to consist of certain information each day? For example, Monday's blog entry could be about artist research, Tuesday's about historical research, and so on. Both methods will give your research some organization.

At the end of the week, look back and re-read your blog. Use the last blog entry of the week to reflect on what you have gathered and learned, and outline how it could take you forward to the next stage of your project. How has the blog made an impact on your project?

61

5.1

**Title: Let's be honest, the weather helped, *from* 'The Atlas Group'**

Source / Artist: Anthony Reynolds Gallery / Walid Raad

Walid Raad is an artist who works with mixed media: installations, performances, photography and video. He is based in New York, but grew up in Lebanon. Since 1999, he has explored the fraught contemporary history of his native country through a fictional research foundation, 'The Atlas Group'. This vast body of photographs, texts, films, and videos purport to chronicle Lebanon's protracted civil war of 1975—1991.

Documents from within the series blend fact and fiction in a way that suggests the highly subjective and contested nature of historical memory. Here, photographs of Beirut's bombed out and bullet-pocked infrastructure are overlaid with brightly coloured dots.

# 5 Research and practice

**After you have been working for a while, research becomes connected to practice in a way that makes the two things hard to separate — the working process becomes second nature. A reflective practitioner automatically engages with research methods and a continuous process of critical analysis right from the start of a body of work.**

Some photographers may state that they do not conduct research, yet everything they have learnt through years of practising and looking at other photographers' work is part of a research process and will have its influence. For example, an advertising photographer working outdoors may spend days measuring changing light conditions at the chosen location before the shoot — this is research. The location itself will have been selected through a careful research process.

From testing the relevance of your work, determining your audience and taking time to view your work from new angles, to the final production decisions on how to present your work, your research will continue to inform your practice.

Like a scientist, a photographer has to test whether what they are doing works in the way they expected; and also whether it is effective for the audience they are intending to reach. Tests can vary from trying out technical methods – such as lighting, camera type, film or digital – through to examining the way the work is going to be produced, and for whom it is being made. A photographer or artist concerned with theoretical discourses will test applying various theoretical concepts through their practice – a very specialized approach. Other tests can include looking at the relationship between the photographer's own work and other related work throughout history. Why does a particular project work at a particular time, and what is its significance in relation to work that has been made before?

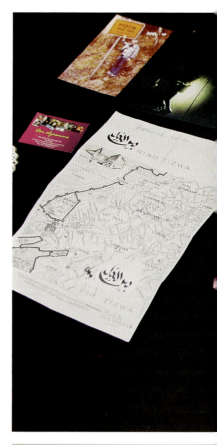

## Methods of testing

Photographers frequently use a wall in their studio or home to pin or tape up images they are testing out. The photographs need to be big enough to be viewed clearly. The photographer may put up different sized prints next to each other to try to judge how changes in scale affect an image or series of images.

Different tones and colour balances may also be tested. Frequently, these images will be left for several weeks as the passing of time slowly affects how the photographer views the work. Visitors to the studio also bring their own comments and these, too, affect the photographer's thinking about the work.

5.2

**Title: Different methods of testing narrative and scale**

Photographer: Natasha Caruana

Photographers have various methods of testing – pinning work to walls, hanging it up, or projecting images when testing large scale – but essentially the intention is the same: to test how photographs look next to each other, to find out the optimum scale, and to analyse the colour and tone of images.

Part of the research process that photographers continually engage with is considering where their photographs might go and who the audience will be. What type of venue or publication would be the best place to convey the meaning of the work?

There are so many contexts for photography that it may be that your work fits into more than one place. When a body of work is ready to have a public profile, you need to consider how the context will affect the meaning of the work and which setting will enable your work to be seen by an appropriate audience. A family album is made for family and friends; a billboard speaks to the masses; a framed photograph in a commercial gallery speaks to a select group of individuals from a world of art buyers, sellers and art lovers. A museum or public space tends to attract a broader audience and has a commitment to education.

## Research ethics

Something else that photographers should continually engage with in their research and practice is the concept of ethics. If you are a student or researcher working within an academic institution, it is likely that the institution will have research ethics guidelines that you will be required to consider and apply to your practice.

When photographing people, you may need to use model release forms, which give you written permission to use a person's image. It is essential to make your subject aware of what you are doing and the context in which their image might eventually be seen. The same applies when conducting interviews — all interviewees need to have comprehensive information about the project and you need to confirm with them that they understand it.

Essentially, developing an understanding of research ethics means you have considered all the possible difficulties — personal, social or political — that your work might encounter when it is revealed to the world.

A professional photographer working outside of academia will not always concern themselves with the same kind of research ethics as academics, but it is likely they will have an ethical code of their own based on personal political beliefs and also informed by the relevant laws that apply where they are working.

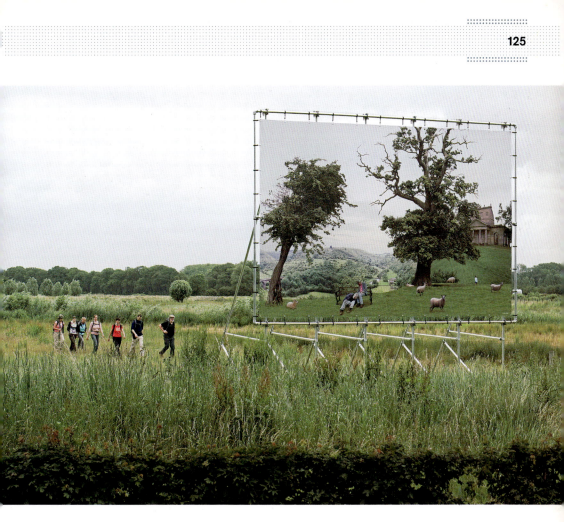

5.3

5.3

**Title: Dreamers, *from* 'High Summer'**

Artist: John Goto

Installation photo: Ernie Buts

There are so many contexts for photography that it may be that your work fits into more than one place.

The curators of the *Idyll and Friction in the Landscape* project in Holland took photographic artworks of landscapes back into the landscape itself, displaying the images on huge, specially constructed billboards. It was a form of montage; setting the idyllic or romantic images against the expansive Dutch countryside, near Sint-Michielsgestel. Visitors could walk or cycle a circular route to see all 20 exhibits in the project. In this case the artwork was placed directly into the community.

Past research, if filed in an accessible manner, is highly valuable. You may want to revisit a project that you feel was not completed properly, or a body of work that could have been developed further. In both cases, the original research material will prove invaluable.

Going back through your archive also gives you a sense of what has been achieved over a period of time and that a history is being recorded. New ideas can often be sourced from research archives as, generally, they hold more material than could have been used when they were originally set up. Photographers regularly revisit their archives and some have particular images or items that crop up as being significant for them time and time again.

## New inspiration from old research

Karen Knorr has been photographing since the late 1970s. Her series, 'Gentlemen' documented life inside private gentlemen's clubs in London: highly privileged patriarchal settings from which women were excluded. Knorr gained access to these clubs and produced a fascinating series of images critiquing these environments.

Twenty-five years later, Karen Knorr revisited the research she conducted for this series in order to create a new one, with a different focus – 'Ladies'. This was made more achievable because Knorr had kept the original research material that sparked her idea many years before.

It can be a joy to revisit old research as you never know where it will lead you; by keeping original research materials you keep open the door for revisiting, reinterpreting and re-appropriating your earlier work.

5.4

**Title: Those Who Fear…** *from* **'Gentlemen'**

Photographer: Karen Knorr

One of the 26 images Knorr created in the 1980s, which used image and text to create a humorous and critical perspective on the patriarchal values of London gentlemen's clubs and their members.

The text featured with each image is drawn from speeches made in Parliament or in the news:

Those who Fear
the Rule of Women
but Love the Monarchy
should reconsider their Prejudice;
to ensure the right
of his Firstborn to the Throne
will create a better Climate.

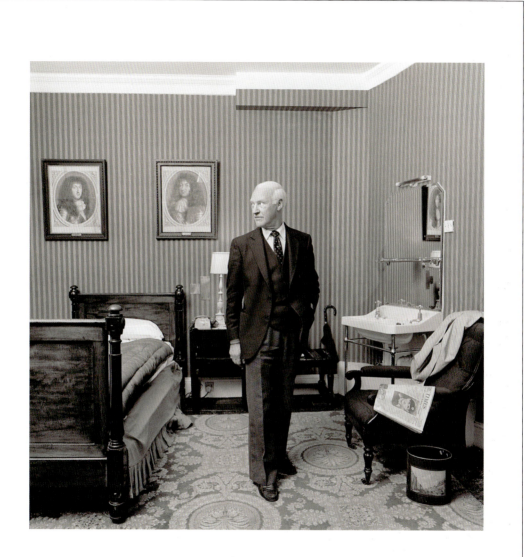

Those who Fear
the Rule of Women
but Love the Monarchy
should reconsider their Prejudice;
to ensure the right
of his Firstborn to the Throne
will create a better Climate.

Thinking time is something that is often overlooked — it sounds like a luxury. However, it gives you an opportunity to look at your images from a different perspective. Taking a sideways glance is an important part of the creative process. It contributes to developing the approach that you take and the way you resolve a project. Try it out and take note of the kind of effect thinking time has on your photography projects.

## Analogue and digital

If you are working with analogue film, there are periods of time between the shooting of the photographs, the processing of the film and the printing of the contact sheet that give you time to imagine how the pictures may turn out. This then mediates how you respond when you finally have a contact sheet in your hands.

It is very different when you shoot using digital as the result can be viewed almost instantly on the screen at the back of the camera. Photographers often delete their digital images quite quickly, sometimes a few seconds after shooting them, making decisions that they would not necessarily have made if they had waited and looked at the image a few days later.

Bearing this in mind, it is interesting to consider how the characteristics of photography could change in the next 25 or 50 years. If all photography is digitally shot, a certain type of photograph will have completely disappeared, particularly in the field of vernacular photography. Photojournalism and sports photography have already changed dramatically and are predominantly digitally shot.

5.5

**Title: Searching for a Figurehead**

Photographer: Natasha Caruana

Part of a long-term series capturing people or objects that represent authority or have a symbolic presence. The photographer passed by this carved figurehead every day during her teenage years. Several years later, she realized the significance the carving had in her daily life, and returned to the site to capture this image.

## Time and editing

Thinking time is also crucial when the photographer is reflecting on the potential edit of their project. Editing may well be done in collaboration with a publisher or a curator, but usually the photographer will have done an initial edit before the project reaches this stage. Potential edits that are being tested out often stay on the photographer's wall for weeks while decisions are slowly made.

## Time and changing meaning

Time can have a profound effect on the meaning of photographs. Longer periods of time, such as ten or 20 years, can considerably alter ways in which photographs are read and understood, especially documentary or reportage photographs that depict a particular time or place. As time passes, perspectives on the world change. On the day of a shoot, an outfit or costume will be understood in a particular way, but the meaning of clothing and style can be transformed through the passing of time. It is fascinating to look at style and costume in photographs from preceding decades. Something that may have seemed ordinary at the time may appear exotic; a dramatic costume can become historically significant.

5.6

**Title: Cheryl, Sloane Square**

Photographer: Derek Ridgers

In the 1970s and early 80s, photographer Derek Ridgers roamed the streets around London's Kings Road with his 35mm camera, looking for punk rockers to photograph. He photographed hundreds of young people during this period and has an extensive archive of the project. These photographs celebrate the inventive dress and style of the period. Ridgers' images from this period have become valuable historical documents as well as being very powerful images in themselves.

Periods of time, such as ten or 20 years, can considerably alter ways in which photographs are read and understood.

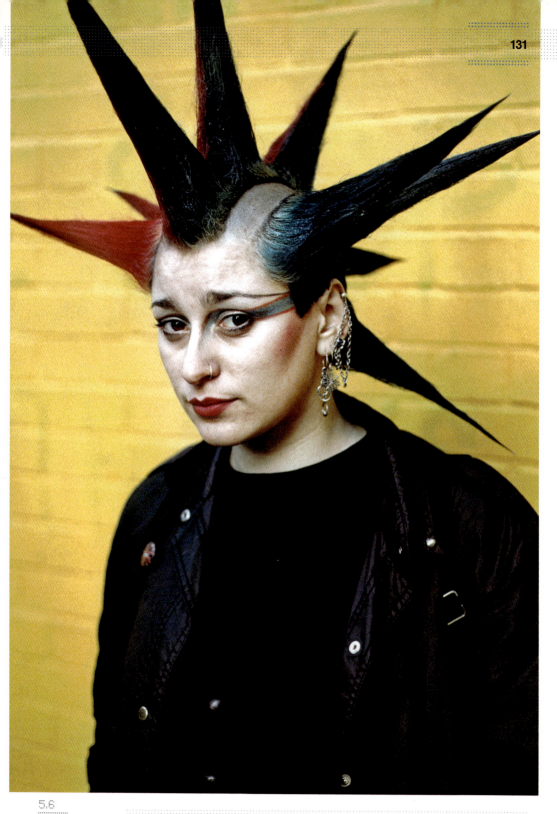

5.6

Numerous issues and ideas may arise during the development of a project and you are best placed to manage these if you are prepared for change. Keeping a positive attitude is useful when there are setbacks; if a project does not have a degree of flexibility it may prove very difficult to accomplish. If, for example, an application for funding is rejected, your proposal can be reworked and resubmitted elsewhere.

One body of work can lead directly into another and several small projects can eventually join to make one much larger one. If you start your research thinking that this is a possibility, then the doors are always open for the growth and development of an idea.

As your plan evolves, it should be updated together with an evaluation of what has changed and why; this will assist you in tracking the evolution of the project and may play a valuable role in future work.

## Using change to your advantage

You may find your project will evolve differently from the way it was originally planned. You could be shooting outside and bad weather may slow down your progress – rather than feeling behind schedule, modify your shooting plan to take this into consideration. This way you can stay positive and in control. Some changes, such as the weather and poor health, cannot be helped. However if, during the creative process, you see that your original intention would be stronger with a different resolution then you must allow space for your plan to naturally evolve with the project.

Wendy Pye has been photographing Beachy Head, on the south coast of England, for more than five years. Making work over this length of time was never her original intention. Pye first planned to explore roadside shrines to the victims of traffic accidents, looking at how society expressed grief. However, being unable to control street lighting frustrated her and slowed her progress. By chance, she came across shrines of a different sort at Beachy Head, known both as a place of natural beauty and as a notorious suicide spot. Pye modified her plan to explore these shrines, and has created several successful pieces through this modified approach. Pye's working relationship with this location was only possible because she was flexible and adapted her original plan.

5.7

**Title: In Memory Of 7… *from* 'Beachy Head'**

Photographer: Wendy Pye

In making this work Pye explored the floral shrines placed as a memorial for the suicide victims who have jumped from one of Britain's highest cliffs. Through quality of light and feeling for nature, these shrines become symbolic of human fragility and our relationship with loss, tragedy and death.

5.7

In the UK during the 1980s, most photography exhibitions tended to be produced in a similar way: prints were usually a maximum of 20 x 24 inches (50 x 61 cm); they were matted and then often framed in simple black or dark wooden frames. There was little to be found that was different in photography exhibitions, except on the occasion when the show had been branded an 'art show', which at that time was rare.

Today, photographers everywhere are interested in exploring the final production and context of their work as an important part of shaping the meaning of their projects. Even details such as the choice of the frame are now considered important.

The growth of the field of photography curation has helped this happen, as well as the acceptance of photography as an art form in its own right. There now seem to be few limits to what can be achieved in the context of an exhibition, though final production decisions will be constrained by available budget.

5.8

**Title: Untitled (We Don't Need Another Hero), billboard installation, London, 1986**

Source / Artist: Mary Boone Gallery/Barbara Kruger

Barbara Kruger is an artist who combines photographs (often from the popular media) and other types of image with text. Sometimes she works with text on its own. She raises direct political questions with her work, and looks to exhibit it as publicly as possible, often displaying large-scale images in public spaces. Kruger's highly original choices of how to exhibit her work have included the use of posters, billboards and shopping bags, amongst other things.

Today, photographers everywhere are interested in exploring the final production and context of their work as an important part of shaping the meaning of their projects.

5.8

## Photographic books

The design and production of photographic books has developed significantly in recent years. Despite the growth of online publishing, the photography book is redefining itself in a niche market; becoming more specialized and often highly priced. Today, more photography books than ever are being published and both photographers and artists have engaged with the possibilities of designing and producing their own books, either as limited-edition artist works or as online productions through companies such as Blurb <www.blurb.com>, where the buyer can pay to print the book on demand.

All of this means that the scope of what a photography book can look and feel like is vast. The physical book still possesses a very special quality in the way that images are read and received; it is an intimate format designed for one person to look at, usually in comfort. Limited-edition publications, in comparison to coffee table books, tend to have a wider range of designs and formats, including newspapers, fanzines, concertina books, books with fold-out pages — the possibilities are almost unlimited. There are specialist bookbinders that can make a whole range of different products worth considering for the final production of your work.

There are numerous collections of limited-edition photography books, for example on <www.thebookroom.net>, where you can see the artifacts for yourself.

5.9

**Title:** *The New Town*, book project and detail

**Photographer: Mårten Lange**

Mårten Lange self-published his limited-edition book, *The New Town*, in 2011, taking total control over the design and format. The project was shot in Milton Keynes, UK, and observes the urban landscape as a post-apocalyptic space. There are no people and only traces of the fabric of the city, photographed as black-and-white details. A set of colour urban landscape images, printed very small on selected pages, function as suggestive spaces that the black-and-white detail images could have emerged from. The book was printed by the online service, Ubyu <www.ubyubooks.com/>.

5.9

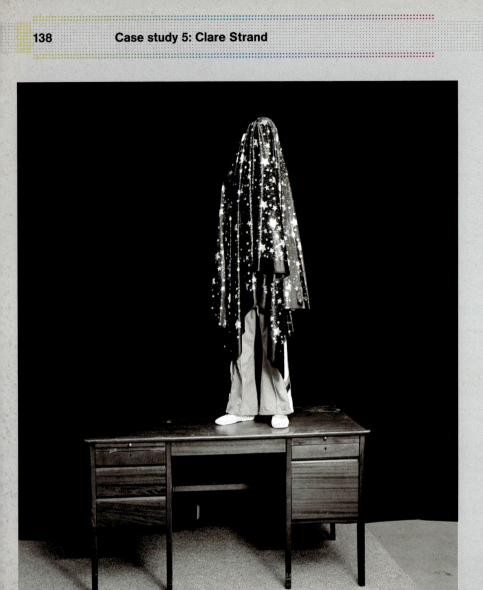

5.10

5.10

**Title: The Appearing Lady**

Artist: Clare Strand

Strand views the modes of presentation of her images – the size of an image, the surface of the paper, the way it is framed or mounted, the use of moving image or a sculptured display – as crucial factors in fully realizing the finished work.

# Case study 5
# Clare Strand

Clare Strand is an artist who has been working with photography for two decades. Her practice has, from the start, been inseparable from her research. Certain images, accrued since her mid-teens, continue to influence her work, and are constantly revisited and reassessed.

Strand studied at the University of Brighton and then the Royal College of Art in London, after which she began to develop her intuitive and personalized approach to image-making. She has continued to evolve her practice into a hybrid art form that draws immense influence from her multifaceted research interests.

Her work is scrupulously planned, researched and executed. Strand has an ongoing passion for utilitarian photography, where the functional overrides the aesthetic. Her past catalogue of work has engaged with the formalism of forensic photography, the mechanics of spirit photography in which images are manipulated to create ghostly visions, and the conventions of signage in photography used in the everyday delivery of information.

Strand views the process she adopts as being akin to a scientist or a detective at work: attempting to solve a puzzle or a mystery. However, she is not particularly interested in solutions, preferring to formulate new questions in place of answers. By taking into account the possibilities of the evidence gathered, she builds her highly constructed images out of appropriate objects, subjects and locations.

Research, intuition and serendipity guide Strand's artistic process and inform the final resolution of the work, whether on the wall of a gallery, the pages of a book, a TV monitor or in a fashion magazine.

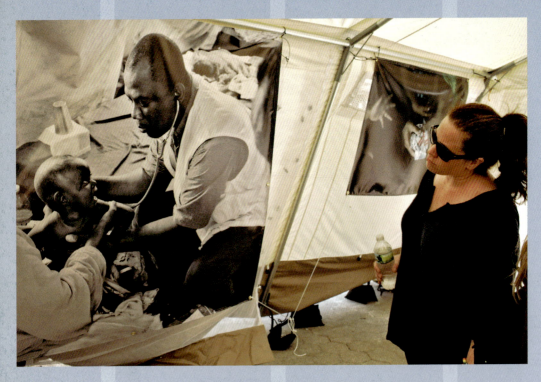

5.11

5.11

**Title: A field hospital is used as an exhibition in New York, to spotlight childhood malnutrition**

Source/Photographer: Getty Images/Spencer Platt

This exhibition was put on by Doctors Without Borders/ *Medecins Sans Frontieres* (MSF) in New York to highlight child malnutrition. The photographs were exhibited in a field hospital which was erected in Union Square.

This put the viewer into the context in which the images of malnourished children were shot. This connection between the images and the exhibition space would have influenced viewers' reactions in a very different way than if the images had been hung on the walls of a conventional gallery.

# Activity 5
# Context and meaning

To complete this activity you need to choose and gain access to a location: it could be a home, an office, a town hall or an institution such as a local museum. You will be gaining access to tell a fictional story about the place, using a combination of photographs, texts and objects, and to create a small exhibition.

Once you have permission to use the location you should photograph it in order to respond to what you find interesting from a purely visual point of view.

The next step is to conduct background research to find out more about the location. Look at its history and its current use – who works, plays or lives inside? What happens there? If it is an institution, what relevance does it have to the community? Record interviews with people related to the location.

When you feel you have enough material, think about the story you would like to tell: what is your point of view or angle? The story can combine fact and fiction, you can exaggerate and fabricate, but remember that your interviewees will see your work.

Once you are happy with your story, create a small exhibition of the work. This can include photographs, text, interview material and objects from your chosen location. You are then going to exhibit your work in two or more locations.

The first exhibition should be in the location you based your story around. Record the responses you get – you may want to be there in person to collect this information through informal conversations, or you may want to leave questionnaires or a visitors' book in a prominent position.

Once you have done this, move your exhibition to a second location, in a different public space. This could be a museum or library, or a university department. As with the first location, you need to record the responses you get here.

When your last exhibition is over, you can compare the feedback and responses you received in each venue, and reflect on how you think the different locations may have affected the interpretation of your work.

# Where **Three Dreams** Cross

### 150 Years of Photography from India, Pakistan and Bangladesh
### 150 Jahre Fotografie aus Indien, Pakistan und Bangladesch

6.1

# 6 The impact of research

6.1

**Title: Cover of *Where Three Dreams Cross***

Source: Steidl/ Whitechapel Gallery

This contemporary publication focuses on 150 years of photography from the Indian subcontinent, and is just one example of the fascinating research being done around global histories of photography today. As research in photography increases, particularly at post-graduate level and beyond, we are able to expand our knowledge about the wider world of photographic practice.

**Research impacts on all aspects of practice, history and theory – as well as more generally on the understanding of the wider context of photographic practice. In order for research to have real impact, the following are vital: access; discussion and thinking; writing; and response making. Research needs to reach an audience, as methods of communication and dissemination of ideas play an important role in conveying new knowledge and debate.**

Exhibitions can play a key role in the interpretation and dissemination of work, but audiences are sometimes limited to the small community of the gallery-going public. Recently, the rapid expansion of web-based exhibitions and blogging have added a new dimension to the understanding of photography and, most significantly, to the wider dissemination of ideas and knowledge. This democratization of information through the Web has markedly affected photographic practices all over the world. Looking into the future, it is possible to see that we will soon have a far greater awareness of the global histories and practices of photography.

Photographers use research, in all its forms, to aid the development of a project. It is important for practitioners to evaluate and reflect on how their research has supported the progress of a body of work. When research goes unrecorded, its significance can be lost or reduced. By making time to be more aware of both the research process and its influences you have more scope to reflect on your working process and apply this knowledge to future work.

### Gaining perspective

Reflection takes place through a process of monitoring and evaluation, producing distinctive information that can help you improve your photographic practice. It helps you to process new knowledge gained through making a body of work. Reflection allows you to stand back, putting distance between you and your work, and frequently increases your awareness of the impact of a body of work. When a photographer has been working intensely on a project, it is difficult to gauge its impact. By standing back, the creator is able to see the work from a fresh viewpoint. This is a vital way of gaining the perspective needed to enable discussion and dissemination of the ideas coming out of your work.

### Recording and reflection

Develop your awareness of how you are making your photographic projects by recording your research in detail.

Try to record the ways in which certain aspects of your research have influenced the way you develop a project.

Use these records to reflect on your work and help you expand what you do and how you research an idea.

How have you changed and refined the way you work through the lifetime of the project and why?

### Keeping a journal

Objective reflection is difficult and does not necessarily occur spontaneously; conditions can be structured to encourage it to happen. Reflection is often most successful in the form of a personal journal that can be written without the anxiety of it becoming public information. The development, research and evaluation progress of a project can be tracked, recorded and reflected on.

A personal journal is a 'partner' in the creative process, in which the development of ideas is recorded and considered reflectively. The aim of reflection is to enhance critical thinking that will contribute to the creative process and ultimately add to the dissemination of innovative work that contributes to contemporary debate and new knowledge in the field.

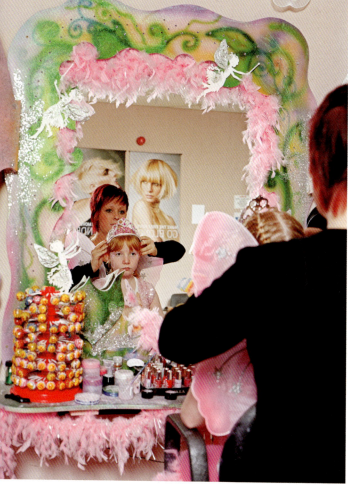

6.2

6.2

**Title: Hair and make-up shop, *from* 'Resort'**

Photographer: Anna Fox

Anna Fox spent two years from 2009 photographing the contemporary face of Butlins, a holiday camp in Bognor Regis, UK. Fox worked through a number of different practical experiments and researched the historical representation of Butlins, as well as the English seaside, before establishing a particular working method. Her final photographs reflect her fascination with the depictions of Butlins made by the John Hinde Studio in the 1970s.

By making time to be more aware of both the research process and its influences you have more scope to reflect on your working process and apply this knowledge to future work.

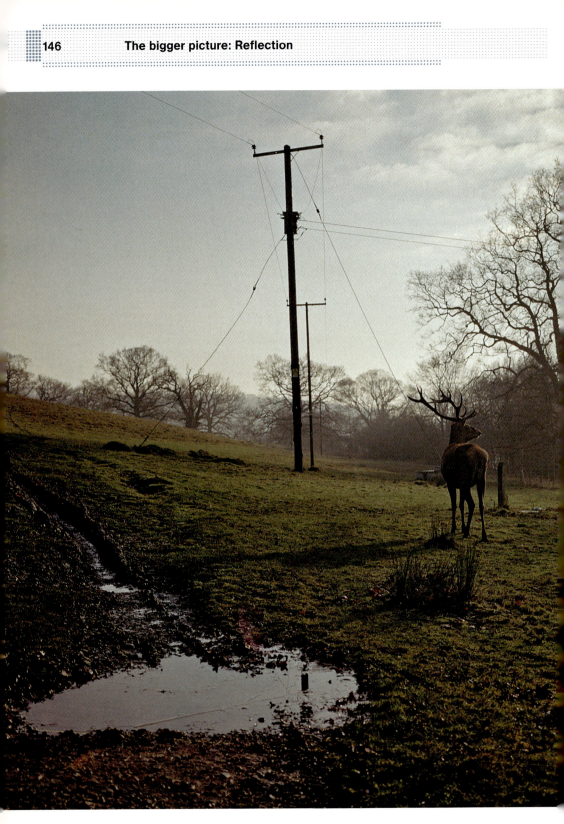

6.3

**Title: Untitled, 2007**

Artist: Melanie Stidolph

When an image such as this unfolds in front of artist Melanie Stidolph, she is simultaneously thinking about composition, reference and final presentation. For each piece, she always shoots a collection of images, later selecting one or two, and always printing them full frame. She undergoes a process of reflection, both at the time of shooting and at the time of editing, using this process to discover a definitive image that transmits an intensity of looking and acts as a conduit for an emotional experience.

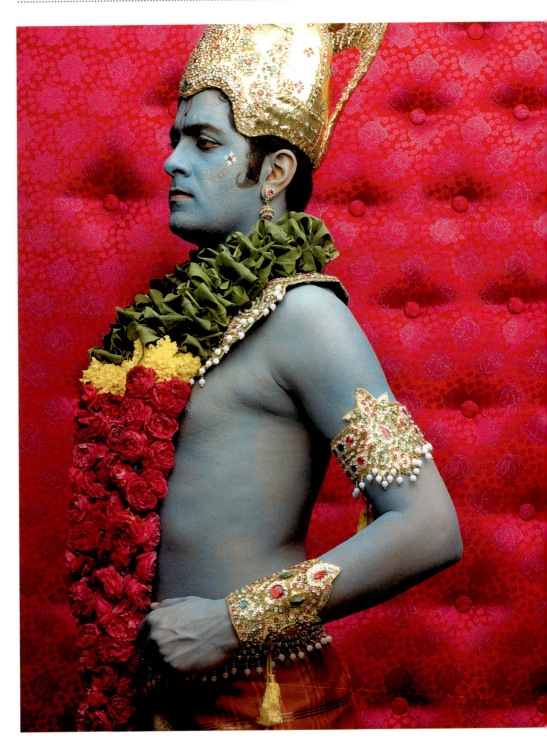

6.4

6.4

**Title: Reassurance, *from* 'Definitive Reincarnate'**

Artist: Nandini Valli Muthiah

This image is from Nandini's series in which she juxtaposes traditional depictions of Indian gods with elements of the modern-day. Here, a vivid block of colour from the bedroom of a boutique hotel creates the backdrop for her subject.

## Historical and cultural contexts

Nandini Valli Muthiah is emerging as one of India's key contemporary artists and her highly constructed photographs rely on the idea of replaying historical ideas within a contemporary context. For her project 'Definitive Reincarnate' Nandini took her research references from the traditions of Indian popular art, researching the history of the painted calendar posters that represent Indian gods. These calendars use both traditional painting and painted photographs to create mythical spaces in which the viewer can dream. Nandini turns around the conventions of this tradition by styling and painting her subjects to resemble the gods in the calendar posters, but presenting them in contemporary spaces such as hotel rooms. In this way the heroism of the traditional poster character is transformed into a more modern myth, allowing the viewer to reconsider the space of the everyday and their relationship to it. Nandini's research into the history of the painted calendar posters was vital to the realization of her project.

An understanding of global histories and a broad cultural knowledge are invaluable both in terms of understanding photographs, and creating them from an informed perspective. It is becoming increasingly important for the discerning student of photography – and the practitioner – to look further afield in their research and practice than areas they are already familiar with. This exploration and sharing of new ideas will ultimately contribute to the growing awareness of global histories and new directions in photography.

Visiting an archive is a great way to engage with research carried out by other photographers. Personal archives belonging to photographers, collectors, writers or curators, tend to be private with access restricted to specialist researchers. Museum archives tend to be more available to public scrutiny, usually through special exhibitions. Access to museum archives outside of exhibitions is usually by appointment only, but you do not always have to justify entry with a bona fide research proposal. For example, students and researchers alike are able to make appointments to look at prints in London's Victoria and Albert Museum photographic print archive – it is a truly fascinating experience to spend time in such a place.

## Personal archives

The photographer's archive, appropriately stored, provides a lifelong source of references and potential material for interpretation, evaluation and understanding. The photographer who meticulously creates such a resource is not only creating a rich mine of information for themselves, they are also building a library of information for other researchers, curators and writers interested in their work and the particular period in which they made it. Such archives can be valuable even after as little as five or ten years from their inception. Studying the thinking, inspiration and development process behind a particular photographer's work affects our understanding of how and why their projects or series have been made.

The photographer's archive provides a lifelong source of references and potential material for interpretation, evaluation and understanding.

6.5

6.5

**Title: The Bank Archive**

Source: Martin Parr

Martin Parr has been collecting books and photography ephemera since the 1970s. His archive contains many hundreds of books from all over the world, numerous artifacts, vernacular photography of all descriptions, book dummies and original prints by various photographers. This is currently a private archive owned solely by Parr, largely used for his own research, although some researchers working on major projects have been granted access to it.

## Hidden archives

Archives are a great resource to help you find out about people, places and periods of time, as well as about particular types of photography. Look out for hidden archives – start in your own attic or family album. You could put an advertisement on a notice board at your college or university asking for people to contact you with information about their archives or about a particular type of photograph. Visit car boot sales, second-hand shops and auctions to find old photographs and postcards for sale.

Revealing usually unseen background research can put a piece of work in a new context and alter its meaning for the viewer. A number of significant exhibitions, such as the Diane Arbus *Revelations* show at the Victoria and Albert Museum (London, 2006), have displayed aspects of the photographer's personal archive as part of the show. In this particular exhibition, the viewer was able to see contact sheets, notebooks and letters, giving a unique insight into the photographer's thought processes. It is more typical for photography exhibitions and publications, both contemporary and historical, to simply show the 'great' photographs or the final photographs selected by the photographer or curator. The Arbus exhibit enabled the audience to peer behind the scenes and get a sense of the photographer's character. This revealed details of the context of the work and made the personality and process behind the final picture as fascinating as the picture itself.

## Writers and curators

When conducting research, it is vital to recognize that the nature of a photographer's work and its meaning have often been affected and shaped by the curatorial process. Discovering how and why curators and writers have conducted their research, and the rationale behind certain curatorial or editorial decisions, is as much a part of the research process as investigating the photographers themselves. Curators and writers are also keen archivists – their archives are often less visible than those of photographers, but they deserve investigation.

## Research centres for photography

Research centres for photography are growing in number. Usually based in universities, they often focus on a particular area of photography research. A research centre is frequently the place where innovation in debate and analysis of research take place. Conferences, seminars and study days are events regularly hosted by research centres. A research centre may also have a specific collection.

The Photography and the Archive Research Centre (PARC) based at University of the Arts, London, is directed by Professor Val Williams, who has been steadily collecting posters and invitations from photography exhibitions since her earliest involvement in photography. PARC has received several major research awards for projects that involved analysing historical material (both written and photographic), alongside commissioning contemporary material. The projects create debate around the relationship between past and present in both vernacular and art-based photographic practices.

6.6

6.6

**Title: Artifacts from an archive**

Photographer: Ali Mobasser

These artifacts are taken from the personal archive of a photographer who has an interest in Iranian material – from the vernacular to news tapes, magazines and found objects.

6.7

6.7

**Title: Photography and the Archive Research Centre, UAL**

Photographer: Afshin Dehkordi

This image shows some of the materials in the Photography and the Archive Research Centre, (PARC), which is part of the University for the Arts, London. The centre specializes in photographic archives, houses special collections and also runs research projects. PARC publishes *Fieldstudy* twice yearly, which explores issues and ideas connected to photographic archives and artists/photographers who work with archives.

6.8

6.8

**Title: Najm (left) and Asmar (right)**

Source: Arab Image Foundation

This image shows two of Hashem el Madani's subjects posing in costumes; one as a cowboy, the other as a bride. The photographer said of the shoot, 'It was a session of disguise. The bride's dress, the hat and the flowers were part of the studio accessories.'

# Case study 6
# Hashem el Madani

**Hashem el Madani is a Lebanese studio portrait photographer. He purchased his first box camera in 1948 and started photographing friends and family. Madani slowly upgraded his photographic equipment by using credit and by selling test images. In 1953, he was able to open his own studio. In the last 50 years, he has taken over 500,000 images.**

The studio was in the town of Saida in southern Lebanon, and Madani claims that 90 per cent of the townspeople passed through his studio doors to have their portraits taken. Through his life's work, he has created a collective portrait of one Middle Eastern town.

Inside Madani's photographic studio people discovered a fantastical environment removed from everyday life, where they could role play and act out their personal dreams. The studio had simple props and Madani used poses cut out of magazines to provide posture guidelines for his sitters to emulate. The people of Saida performed for Madani's camera with humour, honour and sincerity. They acted as themselves, as alter egos or as superheroes, often posing with objects that were important to them. The work forms an important archive and a social commentary.

Madani's work was brought to public attention by the Arab Image Foundation, based in Lebanon, and with the support of the Photographers' Gallery in London. Some of the images from his vast archive can be viewed in the publication *Hashem el Madani Studio Practices*, published by Mind the Gap/The Arab Image Foundation, in 2005.

The layout of the book includes sequences of images illustrating the tests and the preparation leading up to the final portraits. These sequential narratives do not reveal the selected 'final' portraits, so invite the viewer to imagine the final, prized images that were taken home by the subjects.

6.9

**Title: FINDS**

Photographer: Harry Watts

Harry Watts' project 'FINDS' grew from documenting found sculptures left on the streets. His images were then collated and returned to the street in the form of a free printed newspaper. Watts worked with designers to create a professional manuscript to showcase the work. He then placed the newspapers in numerous locations that would target both his key audience and random passers-by.

6.9

# Activity 6
# Booklet

For this final activity, you will make an explanatory booklet to accompany your photographic project.

It is common for a gallery or museum to provide a small booklet, offering further information about the work of a particular photographer or artist. Guides of this sort often give background information about the photographer's life. They frequently go into considerable detail about how the work was made, what influenced it and how the piece should be interpreted.

Visit two local galleries or museums and pick up an information booklet on a current exhibition from each venue. If there are none on display, ask if a press or information pack is available. Look through these guides and summarize the information that is included. How is it laid out? Which images are used? How is the guide valuable to you, the viewer?

Review your research and development and reflect on the key milestones that have directed your project. Pick out eight images to illustrate this journey – you may want to include scanned pages of your sketchbook or a ticket to an exhibition that you visited.

Write some explanatory text to accompany your images. Remember that what you are writing will need to be in an appropriate tone for a visitor encountering your work for the first time.

Next, use a folded sheet of paper to make a mock-up design and layout for your booklet. Where do you want the text to go? What order do you want your images to be placed in? Making a rough model (a dummy) will help you visualize the final layout. After making the dummy you can design the layout of photographs and text. This can be done using programs such as Adobe InDesign, Illustrator or Microsoft Word. Good, and usually simple, design is vital to this activity and you should explore different design options before committing to print.

This exercise will help you to collate and organize your work in a concise, well-designed manner. The design and editing of the booklet will allow further reflection and, most importantly, direct you to consider how an audience will be introduced to your work.

7.1

7.1

**Title: *from* 'Fairytale For Sale'**

Source / Photographer:
Natasha Caruana

For the series 'Fairytale for Sale'
Caruana befriended brides
posting their wedding dresses
for sale online, and they agreed
for her to use their images. The
work uncovers a strange ritual of
newlyweds covering over their own
faces. What remains are bizarre
theatres of marriage; masked
performers have taken to the stage
to act out emblematic scenes.

# Conclusion

**The emphasis of this book has been on understanding, acknowledging and recording the research process in a way that enables critical reflection and evaluation, creating a rich and vibrant resource archive for continual use.**

We have talked primarily from the perspective of the practitioner and have avoided categorizing different approaches as types of research method (valid within pedagogic discourse). The point of the discussion throughout this book has been to inspire and enable reflective photographers.

Photography has an extraordinary history and numerous theories have been applied to its history and practice as part of an analytical research process contributing to the understanding of the medium. One of the most fascinating areas, yet to be extensively researched and written about, is the global history of photography. Most academic enquiry into photography, to date, is based on the history of North American and European (particularly western European) photographic practice, and photographic education is developing quickly in other parts of the world. In the future, this imbalance of knowledge will be redressed and the researcher should always be aware of the lack of primary information available in relation to an international understanding of the practices of photography.

In this book we have brought in some references to that international history, thanks to those members of the global photography community that we have been fortunate enough to have discussion with.

Research is always limited by current knowledge and the most exciting investigations bring new knowledge into the field; innovation in research instigates inspiration for future photographers and artists.

We have looked largely at the field of art practice, as this is where the main focus is found for recording research as part of the practical process. Knowledge gained in the field of art can be transferred to any other type of photographic practice; commercial photographers, journalists and artists alike all look to a wide range of references for the creation of their work and employ strategies for creating images that are discovered through a practical research process.

Knowledge is empowering and the scope of any project or idea expands alongside the development of an understanding of photographic practices, histories and theories.

**Acid-free material** – Acid-free material has a neutral pH that makes it ideal for preserving documents. Many items in photography such as paper, negative boxes and masking tape can be purchased acid free and it is important to be aware of this to ensure the archival stability of your work.

**Cameraless photography** – A photograph does not necessarily have to be made with a camera; in fact, the first photographs ever made were produced without cameras. It is possible to create images using photosensitive materials and different techniques (such as the photogram).

**Darkroom** – A darkroom is a room that can be made completely dark to allow the processing of light-sensitive photographic materials, including photographic film and photographic paper. Analogue printing with an enlarger is carried out in total blackness if printing colour, or with a red 'safe light' if printing black and white.

**Digital production suite** – The digital production suite, or 'digital darkroom', is wherever the photographer prints their work or spends time manipulating the image in post production. Equipment may include computers, scanners, printers, drawing tablets and hard drives.

**Forensic photography** – Forensic photography (also known as crime scene photography) is a field in which photographs are used for their accuracy in recording a scene, so that record may later be used in court or to aid an investigation. Photographs of this kind often use certain lighting, viewpoints and scales in order to give the most accurate representation of the scene.

**Formalism** – Formalism is the concept that the most important element of an image is its form, that is, its purely visual aspects, as opposed to its context or narrative content. Certain photographers may say that they are interested in referencing the formalism of an artist or aesthetic movement, meaning that they wish to reference the 'form' or look of that work.

**Glass negative** – Glass photographic plates preceded photographic film and were used in early photographic methods of the 1800s. A light-sensitive emulsion was applied to a glass plate and then used in a large-format camera (such as with the albumen process).

**Hasselblad camera** – Hasselblad is a Swedish manufacturer of high-quality medium-format cameras. The popularity of these small and well-built cameras means they have gained an iconic status and have a dedicated following of artists, enthusiasts and professionals using them today with both analogue and digital capture.

**Large-format cameras** – Large-format cameras take film sizes from 5 x 4 inch (12.7 x 10 cm) to 10 x 8 inch (25.4 x 20 cm), and even up to 20 x 24 inch (51 x 61 cm). These cameras are heavy and slow to use so they are unsuitable for some applications. However, the added perspective controls, large negative and quality that comes with that often makes them preferable, especially for producing large, detailed prints.

**Linguistics** – Linguistics is the scientific study of human language. Linguistic enquiry can generally be broken down into the study of language structure, language meaning and language in context. Many photographers are interested in the relation between language and photography and also in photography as a language itself.

**Medium-format camera** – Medium-format cameras record images on film or a digital sensor that is larger than the 24 x 36 mm of 35mm film, but smaller than the 5 x 4 inch (12.7 x 10 cm) size which is considered to be large format. Generally this is 6.45 cm, 6 x 6 cm or 6 x 7 cm on 120 film. Medium-format cameras are often considered the ideal mix between quality and portability and are favoured by photography professionals looking for an especially high-quality image.

**Montage** – A composite image produced by blending multiple photographs or text (either digitally or in the darkroom) to create a fully realized final image.

**Photogram** – A photogram is a photographic image made without a camera by placing objects directly onto the surface of a photosensitive material such as photographic paper and then exposing it to light.

**Photographic film** – Photographic film consists of a sheet of plastic coated with a light-sensitive emulsion. Film comes in a range of sizes from small-format roll film to large-format sheet film. Print film turns into a negative when developed, while colour reversal film (otherwise known as slide film or transparencies) yields a positive image.

**Pinhole camera –** A camera that uses only a tiny 'pinhole' instead of a glass lens. Images made by these simple cameras are typified by distortion and aberrations that can be used for creative purposes. The longest ever photographic exposures have been made with pinhole cameras.

**Polaroid –** The pioneering company that introduced instant film in 1948. The film itself contained all of the chemicals needed for developing and fixing the photograph, so the image was usually visible just 30 seconds after the exposure.

**Psychoanalysis –** This is a branch of psychotherapy developed in the late 1800s and early 1900s by Austrian neurologist Sigmund Freud. In psychoanalytic theory it is understood that a large part of human behaviour is determined by irrational drives. Many photographers and artists are interested in delving into the workings of the mind, and psychoanalytical theory has been hugely influential in the way we understand art and photography.

**RSS reader –** Blogs and online magazines often utilize RSS channels. Using an RSS reader (such as Google Reader) you can keep track of all of the blogs and websites that you 'follow' or are subscribed to, and see new posts as soon as they are published. This is the easiest way of keeping track of a large number of sources and quickly and concisely keeping up to date with current ideas and work.

**Small-format cameras –** In the early 1900s when the first cameras were designed to take the perforated 35mm roll film that was used in motion-picture cameras, these were by far the most compact cameras that had ever been seen. Cameras such as the legendary Leica altered the way people held the camera, the angles that people could point their camera and the way the camera was perceived. 35mm soon became the most popular film format due to its compact size and ease of use. In 2000, digital cameras with sensors smaller than 35mm gained in popularity until digital cameras became the standard, from small but high-quality compact cameras (with sensors usually only measuring about 6mm diagonally), to high-quality 'full-frame' digital SLRs with sensors the same size as 35mm film.

**Vintage prints –** These are historical prints made soon after the photograph itself was taken, often by the photographers themselves. Vintage prints are amongst the most valuable and highly sought-after photographs in the art market, and will often be signed and dated by the photographer to prove authenticity. They can reveal a lot about the vision of the particular photographer and the time they lived in.

## Further reading

Badger, Gerry (2010). *The Pleasures of Good Photographs*. Aperture

Berger, John (2008). *Ways of Seeing*. Penguin Classics

Campany, David (2007). *Art and Photography (Themes and Movements)*. Phaidon Press

Cotton, Charlotte (2009). *The Photograph as Contemporary Art.* Thames & Hudson

Cotton, Charlotte; Klein, Alex (2010). *Words Without Pictures.* Aperture / LACMA

Frank, Robert; Kerouac, Jack (Special Edition, 2008). *The Americans*. Steidl

Gadihoke, Sabeena; Kapur, Geeta (2010). *Where Three Dreams Cross: 150 Years of Photography from India, Pakistan and Bangladesh.* Steidl

Gernsheim, Helmut and Alison (1965). *A Concise History of Photography*. Thames & Hudson

Green, David (2003). *Where is the Photograph?* Photoworks

Issa, Rose (2008). *Shadi Ghadirian: a Woman Photographer From Iran.* Saqi Books

Jeffrey, Ian (1981). *Photography: A Concise History*. Thames & Hudson

Langford, Michael (1988). *The Darkroom Handbook*. Ebury Press

Langford, Michael; Fox, Anna; Sawdon Smith, Richard (2010). *Langford's Basic Photography: The Guide for Serious Photographers (9th edition)*. Focal Press

Ritchin, Fred (2008). *After Photography*. W. W. Norton & Co

Sontag, Susan (2008). *On Photography.* Penguin Classics

Varma, Pavan K.; Willaume, Alain (2007). *India Now: New Visions in Photography*. Thames & Hudson

Warner Marien, Mary (2010). *Photography: A Cultural History (3rd edition)*. Laurence King

Wells, Liz (2009). *Photography: A Critical Introduction (4th edition).* Routledge

Wells, Liz (2002). *The Photography Reader*. Routledge

## Magazines and journals

**Aperture**
Fine-art photography magazine, featuring the work of high-profile photographers alongside academic articles.

**Blindspot**
Magazine showcasing new work from contemporary photographers.

**Camerawork Delhi**
A free newsletter that focuses on independent photography in and around Delhi.

**European Photography**
Berlin-based magazine featuring the work of contemporary photographic artists.

**Exit**
Art, fashion and photography magazine.

**Eyemazing**
Magazine featuring international contemporary photography.

**Foam**
International photography magazine. Each issue is themed and split into eight photographic portfolios.

**FOTO8**
Biannual magazine dedicated to international photojournalism and documentary photography.

**Frieze**
Art and culture magazine featuring the work of emerging and established artists, exhibition reviews and interviews.

**Hotshoe**
Contemporary photography magazine featuring portfolios from new and well-known photographers, equipment reviews, industry news and exhibition listings.

**Photography & Culture**
Peer-reviewed journal, featuring research papers and critical writing on photography.

**Photoworks**
Features the work of new and established photographers, critical writing and reviews.

**Source**
Magazine featuring portfolios of contemporary photography and articles.

## Blogs and online magazines

**1000wordsmag.com**
The online version of *1000 Words* magazine, featuring contemporary photographic work.

**5b4.blogspot.com**
Blog examining art and photography related books.

**pixelpress.org/afterphotography/**
Ongoing blog, originally set up to accompany Fred Ritchin's 2008 book *After Photography.*

**alecsothblog.wordpress.com**
US photographer Alec Soth's archived blog.

**americansuburbx.com**
American Suburb X is an online photography and culture magazine.

**amysteinphoto.blogspot. com/** New York-based fine art photographer Amy Stein's blog.

**caroleevans.blogspot.com/**
London-based photographer Carole Evans' blog.

**jmcolberg.com/weblog/**
Conscientious – independent blog on contemporary fine art photography.

**contacteditions.co.uk/blog/**
Photography blog kept by London arts organization Contact Editions.

**flakphoto.com**
Flak Photo is an online photography magazine.

**huhmagazine.co.uk**
HUH is an online arts and culture magazine.

**horsesthink.com**
Horses Think is a New York-based photography blog.

**hotshoeblog.wordpress.com/**
*HotShoe* magazine's contemporary photography blog.

**iconicphotos.wordpress.com**
Blog featuring articles on iconic images.

**itsnicethat.com**
Online arts, fashion and photography magazine.

**selfpublishbehappy.com**
Website showcasing self-published books.

**wanderingbears.co.uk**
Online creative community with international guest bloggers.

**p3** and **83:** © Helen Sear, courtesy of Klompching Gallery.

**p7:** Wiebke Leister, from the series 'Ever After' (2008).

**p10:** Image by Ellie Davies. www.elliedavies.co.uk All rights remain with the artist.

**p12:** Steffi Klenz, courtesy of the artist.

**p15:** David Moore, from the series, 'The Last Things' (2008).

**p17:** Pedro Vicente.

**p20-21:** Courtesy of Thames and Hudson.

**p23:** © Robert Frank, from *The Americans*, courtesy of Steidl.

**p23:** Rose Issa Projects and Saqi Books.

**p25:** *Photography: A Critical Introduction*, cover image 'Babel' from the series 'Cockaigne' (2004), © Gayle Chong Kwan. Cover provided courtesy of Routledge.

**p25:** *Photography & Culture*, courtesy of Berg Publishers, an imprint of Bloomsbury Publishing Plc.

**p25:** *On Photography*, © Susan Sontag, courtesy of Penguin.

**p30:** Courtesy of the artist, Jeff Wall, and Marian Goodman Gallery, New York.

**p33:** B. O'Kane/Alamy.

**p34:** National Media Museum / SSPL.

**p35:** Courtesy of the Museum of Farnham.

**p37:** Courtesy of Phillip Reed.

**p39:** Lisa Johansson / Millennium Images.

**p41** and **60:** © Andrew Bruce.

**p43:** Yuri Gomi.

**p44:** © The Alkazi Collection of Photography.

**p45:** © Alpha Press.

**p46:** Stephen Bull.

**p47:** Joachim Schmid.

**p50:** © Contact Editions.

**p52-53:** Courtesy of Grace Lau.

**p55:** Images by Sally Verrall.

**p56:** Angus McBean photograph (MS Thr 581). © Harvard Theatre Collection, Houghton Library, Harvard University.

**p56:** Courtesy of the artist, Neeta Madahar.

**p62:** Jo Longhurst. Four photographs on aluminium disks, 2005.

**p65** and **153:** Courtesy of the artist, Afshin Dehkordi.

**p66** and **69:** © Anna Linderstam.

**p68:** From the series, Moronic, 2011.

**p73:** Photo by Vivian Maier / Courtesy of Maloof Collection.

**p75:** Charmian Edge / Anthony Luvera.

**p76-77:** © Melanie Manchot, courtesy of Galerie m, Germany.

**p79:** © John Davies 2000.

**p83:** Maria Kapajeva.

**p85:** 'Powersuit editorial' image, shot for *Muse Magazine*. Courtesy of the photographer, Robert Wyatt. Model: Hanne Gaby, represented by Storm.

**p88:** © Dean Hollowood.

**p89:** © Louis Fox.

**p91:** © Richard Nicholson.

**p92:** © Richard Sawdon Smith.

**p93:** © Joy Gregory 2002.

**p95** and **127:** © Karen Knorr.

**p96-97:** © Martha Rosler / courtesy of Mitchell-Innes & Nash, New York.

**p99:** Chris Linaker.

**p104:** Helen Goodin.

**p106:** © The Metropolitan Museum of Art/Art Resource/Scala, Florence.

**p106:** Lauren Elizabeth Ashley; Matt Freeman; Tom Fry; Natalie Faye Lipscomb; Rory Manzaroli; Bobby Mills; Tom Smeeth.

**p108:** © Fiona Crisp, courtesy of Matt's Gallery, London.

**p111:** Simon Aeppli.

**p112:** © Carole Evans.

**p114** and **152:** Courtesy of Ali Mobasser.

**p116:** © Victoria and Albert Museum, London.

**p118:** Gabriela Herman.

**p120:** The Atlas Group/Walid Raad. Let's be honest, the weather helped. © Walid Raad, courtesy Anthony Reynolds Gallery, London.

**p125:** Photo courtesy of Ernie Buts.

**p131:** © Derek Ridgers.

**p133:** © Wendy Pye 'In Memory of 7...'

**p135:** © Barbara Kruger, courtesy Mary Boone Gallery, New York.

**p137:** Mårten Lange, 2011.

**p138:** Courtesy of Clare Strand.

**p140:** © 2011 Getty Images.

**p142:** *Where Three Dreams Cross: 150 Years of Photography from India, Pakistan and Bangladesh*, by Whitechapel Gallery, Fotomuseum Winterthur. Published by Steidl & Partners/www.steidlville.com.

**p146-147:** Courtesy of the artist, Melanie Stidoloph.

**p148:** © Nandini Valli Muthiah

**p151:** Courtesy of Martin Parr.

**p154:** Studio Shehrazade, Saida, Lebanon, 1950s. Excerpt from Akram Zaatari's 'Objects of Study' project, 2006. © Arab Image Foundation.

**p156:** Harry Watts.

All other photographs and images are courtesy of the authors, Natasha Caruana and Anna Fox:

www.natashacaruana.com
www.annafox.co.uk

All reasonable attempts have been made to trace, clear and credit the copyright holders of the images reproduced in this book. However, if any credits have been inadvertently omitted, the publisher will endeavour to incorporate amendments in future editions.

We would like to thank all those people who have supported us in the making of this book through sharing their ideas and research knowledge. We also thank all those photographers and artists who have generously contributed their images.

With special thanks to the University for the Creative Arts at Farnham; Hilaire Graham; Afshin Dehkordi; Andrew Bruce; Maria Kapajeva; Greg Hobson and Cheryl Cran.

Thanks also to Susannah Jayes for her picture research and to all the AVA staff directing and working on this production, in particular Renée Last and Jacqui Sayers.

# BASICS

# CREATIVE PHOTOGRAPHY

## Working with ethics

Lynne Elvins
Naomi Goulder

## Publisher's note

The subject of ethics is not new, yet its consideration within the applied visual arts is perhaps not as prevalent as it might be. Our aim here is to help a new generation of students, educators and practitioners find a methodology for structuring their thoughts and reflections in this vital area.

AVA Publishing hopes that these **Working with ethics** pages provide a platform for consideration and a flexible method for incorporating ethical concerns in the work of educators, students and professionals. Our approach consists of four parts:

The **introduction** is intended to be an accessible snapshot of the contemporary ethical landscape, both in terms of historical development and current dominant themes.

The **framework** positions ethical consideration into four areas and poses questions about the practical implications that might occur. Marking your response to each of these questions on the scale shown will allow your reactions to be further explored by comparison.

The **case study** sets out a real project and then poses some ethical questions for further consideration. This is a focus point for a debate rather than a critical analysis, so there are no predetermined right or wrong answers.

A selection of **further reading** for you to consider areas of particular interest in more detail.

Ethical: awareness/ reflection/ debate

Working with ethics

# Introduction

Ethics is a complex subject that interlaces the idea of responsibilities to society with a wide range of considerations relevant to the character and happiness of the individual. It concerns virtues of compassion, loyalty and strength, but also of confidence, imagination, humour and optimism. As introduced in ancient Greek philosophy, the fundamental ethical question is: *what should I do?* How we might pursue a 'good' life not only raises moral concerns about the effects of our actions on others, but also personal concerns about our own integrity.

In modern times the most important and controversial questions in ethics have been the moral ones. With growing populations and improvements in mobility and communications, it is not surprising that considerations about how to structure our lives together on the planet should come to the forefront. For visual artists and communicators, it should be no surprise that these considerations will enter into the creative process.

Some ethical considerations are already enshrined in government laws and regulations or in professional codes of conduct. For example, plagiarism and breaches of confidentiality can be punishable offences. Legislation in various nations makes it unlawful to exclude people with disabilities from accessing information or spaces. The trade of ivory as a material has been banned in many countries. In these cases, a clear line has been drawn under what is considered unacceptable.

But most ethical matters remain open to debate, among experts and lay-people alike, and in the end we have to make our own choices on the basis of our own guiding principles or values. Is it more ethical to work for a charity than for a commercial company? Is it unethical to create something that others find ugly or offensive?

Specific questions such as these may lead to other questions that are more abstract. For example, is it only effects on humans (and what they care about) that are important, or might effects on the natural world require attention too?

Is promoting ethical consequences justified even when it requires ethical sacrifices along the way? Must there be a single unifying theory of ethics (such as the Utilitarian thesis that the right course of action is always the one that leads to the greatest happiness of the greatest number), or might there always be many different ethical values that pull a person in various directions?

As we enter into ethical debate and engage with these dilemmas on a personal and professional level, we may change our views or change our view of others. The real test though is whether, as we reflect on these matters, we change the way we act as well as the way we think. Socrates, the 'father' of philosophy, proposed that people will naturally do 'good' if they know what is right. But this point might only lead us to yet another question: *how do we know what is right?*

**You**
**What are your ethical beliefs?**

Central to everything you do will be your attitude to people and issues around you. For some people, their ethics are an active part of the decisions they make every day as a consumer, a voter or a working professional. Others may think about ethics very little and yet this does not automatically make them unethical. Personal beliefs, lifestyle, politics, nationality, religion, gender, class or education can all influence your ethical viewpoint.

Using the scale, where would you place yourself? What do you take into account to make your decision? Compare results with your friends or colleagues.

**Your client**
**What are your terms?**

Working relationships are central to whether ethics can be embedded into a project, and your conduct on a day-to-day basis is a demonstration of your professional ethics. The decision with the biggest impact is whom you choose to work with in the first place. Cigarette companies or arms traders are often-cited examples when talking about where a line might be drawn, but rarely are real situations so extreme. At what point might you turn down a photographic project on ethical grounds and how much does the reality of having to earn a living affect your ability to choose?

Using the scale, where would you place a photographic project? How does this compare to your personal ethical level?

01  02  03  04  05  06  07  08  09  10

01  02  03  04  05  06  07  08  09  10

## Your specifications
### What are the impacts of your materials?

In relatively recent times, we are learning that many natural materials are in short supply. At the same time, we are increasingly aware that some man-made materials can have harmful, long-term effects on people or the planet. How much do you know about the materials that you use? Do you know where they come from, how far they travel and under what conditions they are obtained? When your photography or materials is no longer needed, will it be easy and safe to recycle? Will it disappear without a trace? Are these considerations your responsibility or are they beyond your control?

Using the scale, mark how ethical your material choices are.

## Your creation
### What is the purpose of your work?

Between you, your colleagues and an agreed brief, what will your creation achieve? What purpose will it have in society and will it make a positive contribution? Should your work result in more than commercial success or industry awards? Might your photography help save lives, educate, protect or inspire? Form and function are two established aspects of judging a photograph, but there is little consensus on the obligations of visual artists and communicators toward society, or the role they might have in solving social or environmental problems. If you want recognition for being the creator, how responsible are you for what you create and where might that responsibility end?

Using the scale, mark how ethical the purpose of your work is.

01 02 03 04 05 06 07 08 09 10

01 02 03 04 05 06 07 08 09 10

Working with ethics

One aspect of photography that raises an ethical dilemma is that of inherent truth or untruth in manipulating images, particularly with the use of digital cameras. Photographs have, arguably, always been manipulated and at best they represent the subjective view of the photographer in one moment of time. There has always been darkroom manipulation through retouching or double exposures, but these effects are far easier to produce digitally and harder to detect. In the past, the negative was physical evidence of the original, but digital cameras don't leave similar tracks.

While creative photography might not set out to capture and portray images with the same intent that documentary photography might, is there an inherent deception in making food look tastier, people appear better looking or resorts look more spacious and attractive? Does commercial image manipulation of this kind set out to favour the content in order to please, or is it contrary to public interest if it results in a purchase based on a photograph that was never 'the real thing'? How much responsibility should a photographer have when the more real alternative might not sell?

Bernarr Macfadden's *New York Evening Graphic* was dubbed 'the Porno Graphic' for its emphasis on sex, gossip and crime news. In the early 1920s, Macfadden had set out to break new ground and publish a newspaper that would speak the language of the average person. One of the paper's trademark features was the creation and use of the composograph. These were often scandalous photographic images that were made using retouched photo collages doctored to imply real situations. The most notorious use of the composograph was for the sensational Rhinelander divorce trial in 1925.

Wealthy New York socialite Leonard Kip Rhinelander married Alice Jones, a nursemaid and laundress he had fallen in love with. When word got out, it was one of high society's most shocking public scandals in generations. Not only was Alice a common maid, it was also revealed that her father was African American. After six weeks of pressure from his family, Rhinelander sued for divorce on the grounds that his wife had hidden her mixed-race origins from him. During the trial, Jones's attorney had requested that she strip to the waist as proof that her husband had clearly known all along that she was black.